C000213207

IMAGES
of America

RANCHES AND AGRICULTURE IN NEVADA COUNTY

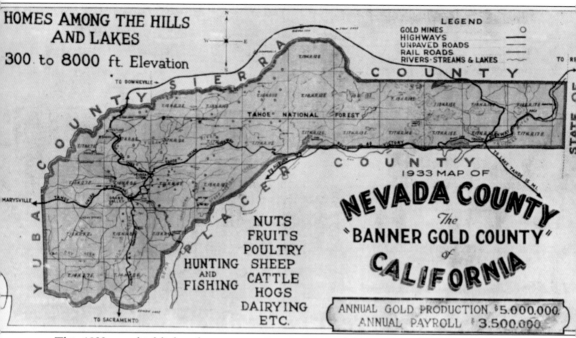

This 1933 map highlights the many opportunities available in Nevada County. It was part of a promotional pamphlet jointly sponsored by the Nevada County Farm Bureau; the Nevada County Development Board; and the Nevada City, Grass Valley, and Truckee Chambers of Commerce to promote Nevada County land and its prosperity in both agriculture and mining. (Author's collection.)

ON THE COVER: Almost every ranch family has photographs of haying. Although it was a lot of hard work, it must have had an element of fun and satisfaction when it was completed since it was memorialized in so many families' photographs. The individuals in the cover photograph are unidentified, and the date the photograph was taken is not known. (Ronald Sturgell Collection.)

IMAGES
of America

RANCHES AND AGRICULTURE IN NEVADA COUNTY

Maria E. Brower

ARCADIA
PUBLISHING

Published by Arcadia Publishing
Charleston, South Carolina

Printed in the United States of America

Library of Congress Control Number: 2017952571

For all general information, please contact Arcadia Publishing:
Telephone 843-853-2070
Fax 843-853-0044
E-mail sales@arcadiapublishing.com
For customer service and orders:
Toll-Free 1-888-313-2665

Visit us on the Internet at www.arcadiapublishing.com

*To my husband, Jim, for sharing this great adventure with
me and being my Uber driver in the midst of snow, hail,
heavy downpours, mudslides, and collapsing roads.*

CONTENTS

ACKNOWLEDGMENTS

To the following generational ranch and farm families in Nevada County—without your generosity, time, and willingness to share your stories and photographs, this book would not have been possible: Myra Davies-Easley and family, Arbogast Ranch; Chris Bierwagen and family, Bierwagen Farms; Gaylene and Kevin Collins and Tim Smith and family, Nichols Ranch; Rob and Victoria Graham and family, Flying MB Ranch; Pat and Nita Browning and family, Tom Browning and family, Browning Ranch; Jim and Barbara Tryon and family, Butler Ranch; David and Barbara Gallino and family, Gallino Ranch & Dairy; Duane and Kathy Niesen and family, Niesen Ranch; Linda Miller and family, Miller-Personeni Ranch; Susan Hoek and Neil Robinson and family, Robinson Ranch; Don and Gary Sweet and families, Sweet Ranch; Darryl and Brenda Sanford and family, Sanford Ranch; and Darlene Moberg and family.

A very special thank-you to Jan Blake and Sabrina Nicholson, of the Nevada County Resource Conservation District, for their assistance, sharing of photographs and material on farms and ranching, and—mostly—for their encouragement.

Thanks to Elaine Sturgell for the use of the cover photograph from the Ronald Sturgell Collection, to Barbara Jensen and Anne Green, and a very special thank-you to Jason White of Grass Valley Printers.

Some of the photographs in this volume appear courtesy of the following sources, which are referred to by the following abbreviations in courtesy lines throughout the book: Nevada County Resource Conservation District (NCRCD), Nevada County Narrow Gauge Railroad Museum (NCNGRM), Doris Foley Library for Historical Research (DFL), and the author's collection (AC).

INTRODUCTION

While this book is about how ranching and agriculture developed in Nevada County, it features 14 historic, generational ranch and farm families whose descendants are still living in the area and working the land. While some of their pioneer ancestors came for other reasons, the majority came to mine for gold. Due to the California Gold Rush, California's settlement was unlike that of any other state in the country. Gold, lumber, and agriculture were intertwined from the earliest days of settlement in the area.

At one time, Nevada County was said to be the most prosperous mining county in the United States, and its number-one industry was gold. The county's literal golden age began shortly after James Marshall discovered gold in Coloma, in El Dorado County, in 1848, continued through the subsequent California Gold Rush, and lasted until the last hard-rock mine closed in 1956. The Empire Mine was the largest gold mine in the world at the height of its 107-year operation. It did not close due to a lack of gold deep down in the labyrinth of tunnels of the underground mines but due to the price of gold, the cost of its recovery, and a strike by the local labor union. All of these factors worked together to herald the downfall of the Empire Mine.

Other major area industries—lumber and agriculture—began almost concurrently with mining due to both necessity and convenience. Lumber was used in early mining to build dams and flumes for transportation and to construct crude shanties in the mining camps for use as temporary housing. Several of the mining camps in the area that would become Nevada County—Nevada City, Grass Valley, North San Juan, Rough and Ready, and French Corral—grew quite large and became booming Gold Rush towns. While most of the easy gold was panned out from rivers and streams in the early days of the Gold Rush, gold quartz was discovered at Grass Valley in 1850 and started a new era of mining in California. As hard-rock mining increased due the abundance and richness of quartz veins found in the area, lumber was needed to shore up the extensive underground mines for which Nevada County became famous. Today, of these three major early industries, only agriculture continues countywide.

The land in Nevada County equaled if not surpassed producing lands elsewhere in California. At the lower elevations, the cultivation of grapes thrived, as well as that of olives, almonds, figs, walnuts, peaches, apples, pears, cherries, berries, and apricots. Local farmers grew vegetables of every variety, and large, healthy specimens were brought into town to be put on display for all to see. The produce was lauded in the *Nevada Daily Transcript*, and word spread outside the local area. The foothills and mountains afforded some of the best grazing land in the state. Some miners soon realized that not only was mining unreliable, but if they were going to survive, they needed to turn to some other occupation. Others gave up the pick and shovel altogether for the spade and plow.

Before the end of the Gold Rush, there was a ready market to sell vegetables, fruit, produce, meat, chickens, eggs, and milk to the large population of miners. Because mining was not reliable day to day—or even month to month—the economy was always in flux. The Gold Rush was over by the mid-1850s. Men left California by the thousands, but this was offset in a way because the eyewitness accounts and news of the richness of land and mild climate in California had been taken back "to the states" and beyond. This brought a steady flow of settlers to California. Other men secured land in the state before leaving to go back home, sell their farms or businesses, and bring their families to California. Still others who left in the dull times went back home to live for a while but soon realized that there was more opportunity in California at that time that anywhere else in the United States. Large tracts of land were homesteaded or purchased for ranches and cleared of brush and cultivated. The new landowners purchased horses, sheep, and cattle that had to be brought in by ship to San Francisco, transferred up the river to Sacramento or Marysville, then led by wagon or on foot into the foothills in the years before the Transcontinental Railroad was completed on May 10, 1869.

With only 24,000 agricultural producers for the entire state of California in 1872, the value of wheat, barley, oats, hay, alfalfa, grapes, fruit, wool, butter, cheese, and hides produced in the state that year totaled $75 million. Due to the still relatively small general population in the state, $50 million of that was exported out of the state. Over the previous 15 years, the growth of California's population had been slow compared to that of the new states on the Atlantic side of the Rocky Mountains. While California had natural advantages afforded by climate and rich soil, what the state needed most was to encourage immigration with a focus on the state's agricultural capacity. In the state's earliest years, agriculture had not received the same encouragement and financial backing as the most profitable industry, mining, especially in mineral-wealthy counties like Nevada County.

In June 1883, the directors of the El Dorado District Agriculture Association approached Nevada County officials to discuss holding the El Dorado District Fair in Nevada County. The district included the counties of Nevada, Placer, El Dorado, Amador, Alpine, and Mono. This was a large undertaking, and it was to be entirely funded by subscriptions. The organizers hoped that the fair would, first, benefit the people of the county, and second, convince the world that the mountains of California can produce something more than gold, silver, and copper.

The fair being held in Grass Valley was the first effort on a countywide level to promote the natural advantages and richness of agriculture in Nevada County. The 1883 fair was so successful that the El Dorado District Fair board agreed to hold the 1884 fair in Grass Valley.

Over the next two decades, articles in local newspapers lauded the variety of goods produced in Nevada County. Newspaper editors and experts alike more than hinted that the hills and valleys of the county could support a large population with many opportunities, and that with the water and soil in the area, dairying, poultry-raising, farming, ranching, and fruit-growing would be profitable. The early 20th century finally brought forth an organized effort to promote Nevada County to the outside world.

DESIRABLE HOMES AND LANDS

OFFERED FOR SALE BY THE

Nevada County Land Improvement Association.

\$8,000.—A Splendid Investment. Choice Farm of 400 acres situated on the Narrow Gauge Railroad about 3 miles from Grass Valley. 150 acres under splendid cultivation. Fine meadow lands that never fail a full crop. Choice fruit tracts in deep red soil. A number of never failing springs. Good house and barn. Water conducted to the barn. There is timber enough on this place to twice pay for the land at regular stumpage price.

\$2,250.—A Rare Chance. 335 acres situated in the natural fruit belt of the county. 60 acres under cultivation. Good house and barn; good well. Situated on the public road and only 4 miles from Grass Valley and 2 miles from Railroad. Good orchard; vegetables and fruits of all kinds grown in abundance without irrigation. Fine timber tract on the land. A splendid purchase.

\$14,000.—A Beautiful Farm of 640 acres, situated in a sheltered locality in the warm belt formerly known as Penn Valley. Deep rich soil, free water, well fenced, good house and barn, sheds, hay presses, etc. Much of the land is well situated for the growing of all kinds of fruit. The pasture land is so located that it commands a large scope of free outside range for cattle.

\$3,000.—Choice and early selected farm of 160 acres, situated on the road from Pleasant Valley to Grass Valley; well located and can be irrigated from a ditch. A number of good springs on the place and is a real bargain at the price.

\$500.—160 acres of choice land to be sold at the price named to settle an estate and is situated on the road leading from Lake City to Columbia Hill. Must be sold. Splendid chance for investment.

\$1,600.—30 acres of improved orchard land situated in the warm belt within one mile of Nevada City. Good house and barn. Rock milk house and other buildings. This property is very favorably situated with plenty of free water. With little improvement could be made worth $5,000.

\$700.—A splendid chance for a party with small means to purchase an improved orchard tract well located, within one mile of Nevada City. 4,000 vines in bearing, 100 assorted fruit trees, 20 pear trees. Water is conducted all over the place.

\$3,300.—Home and Garden, containing 48½ acres, 3½ acres in city limits; 2 good houses, barn, sheds, etc., 500 grape vines, 400 blackberry, 100 strawberry, 40 peach trees, 50 apple, and a fine variety of fruits, all under a fine state of cultivation, and situated on the road leading from Nevada City to Grass Valley.

\$2,200.—A good farm, 104 acres, very favorably situated about two miles from Nevada City; good house, barn, etc., with two horses and seven cows, seven dozen chickens, saddle, harness and small farming implements, seven tons of hay, good spring and water ditch.

\$2,550.—A new house within 3 blocks of business portion of the city, containing 8 rooms, bath, cellar, woodshed and stable. A beautiful situation.

\$3,000 Ranch.—190 acres, patented; 4 miles from Railroad; 60 acres under cultivation. Good house of 12 rooms, barn and houses; natural water; suitable for fruit, grain or stock.

\$1,600 Ranch.—127 acres, patented; 120 acres possessory title; plenty of water for irrigation; 50 acres under cultivation; 3,000 grape vines; 150 fruit trees; house, barn, sheds, etc.

\$2,000.—Wood tract and orchard; 320 acres, patented; 10 acres cultivated; 1½ acres orchard, with house, barn and other improvements. Only 4 miles from Nevada City.

\$1,200.—Dwelling house of 9 rooms, Bowlder Street, Nevada City. A good investment.

\$700.—A cottage with 2 3-10 acres of land; orchard, garden, etc., with good facilities for irrigation; just outside the limits of Nevada City.

\$2,250.—Dwelling of 7 rooms, centrally located in Nevada City; in perfect repair; good cellar and plenty of fine fruit; lot 65x160 feet. One of the most desirable residence properties in the county.

4

Shown above is page 53 of the 1886 booklet *Nevada County, the Famous Bartlett Pear Belt of California.* One of the functions of the Nevada County Land Improvement Association was to act as a general real estate agency to assist the immigrant in buying land through the organization and to provide a list of all government land in the county that was available for settlement by patent or homestead. (AC.)

N E V A D A C O U N T Y - C A

When Nevada County was created in 1851, it contained almost 1,200 square miles. For several decades, there was an ongoing boundary dispute with Sierra County. In 1864, the area was surveyed to determine the source of the South Fork of the Yuba River. It was determined that the branch where the English Dam was located was the true South Fork. In 1902, Sierra County asked for the Surveyor General of California to survey the portion of the boundary that was in question, and a second survey was taken in 1903. Sierra County claimed they had tried to get Nevada County to agree upon the line then establish on the ground. A suit was filed in 1907, and on December 9, Judge John D. Goodwin decided in favor of Sierra County. Nevada County lost over 200 square miles, making the county's area 974 square miles. (NCRCD.)

One

WATER

FLUMES, DITCHES, AND THE NEVADA IRRIGATION DISTRICT

Water is the most important commodity in both agriculture and mining. The early-day miners in California developed a system of taking water from its source to the mines. In 1850, four early Nevada City residents and miners—Charles Marsh, Thomas and John S. Dunn, and William Crawford—came up with the idea of constructing a ditch to move water over long distances. The Rock Creek Ditch that they constructed took water from Rock Creek to the mines near Sugar Loaf, above Nevada City—a distance of six miles. The ditch took four months to build and cost $10,000. This first ditch proved to be so successful that Marsh, John S. Dunn, and James Whartenby formed the South Yuba Canal Company and, in 1854, constructed the Snow Mountain ditch. It had a capacity of 150 miner's inches, and enough water was sold in the first month that they made enough money to pay for the construction, which cost $360,000. They sold water to the first miners using it for $1 per inch. Men in other areas of the county were constructing similar ditches.

As gravel deposits were discovered on higher ground where there was no nearby water source, hydraulic mining brought water across great distances, while monitors were used to blast away hillsides and mountains in order to recover gold from the gravel. Early local farmers and ranchers either bought water from the ditch companies or constructed their own ditches if they had an available source on their property besides groundwater. In the 1880s, the California Legislature authorized the formation of irrigation districts, and local entities were given the power to develop irrigation systems and reservoirs to store water for use during the irrigation season. Nevada County farmers made many attempts to produce an adequate supply of irrigation water.

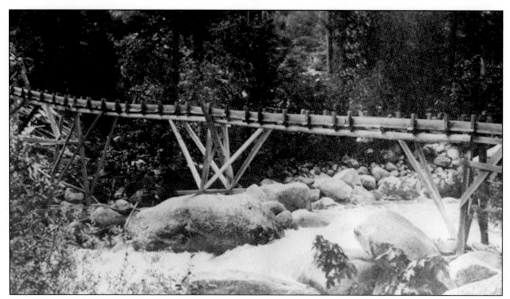

Flumes—wooden chutes used to convey water over long distances—could be built over terrain where common ditches could not be dug, as shown here. The average life of a flume was about six years, and they periodically had to be repaired. An average flume was constructed with one-and-a-half-inch-thick boards and was usually 40 inches wide by 20 inches deep. (AC.)

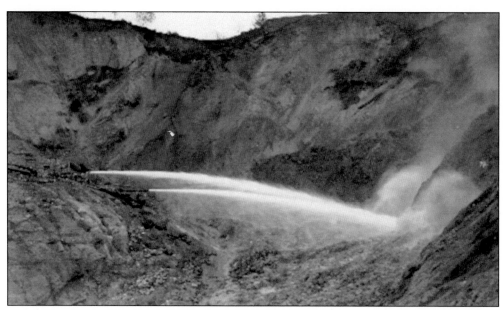

Early hydraulic mining involved using iron pipes with a hose nozzle on the end. The invention of the "monitor" increased the volume of the water and caused pressure that discharged a shaft of water so powerful it could toss rocks weighing tons as if they were mere pebbles. In the process, the force of the water destroyed the hillsides as it washed out the gold-bearing gravel and wasted immeasurable amounts of water. (AC.)

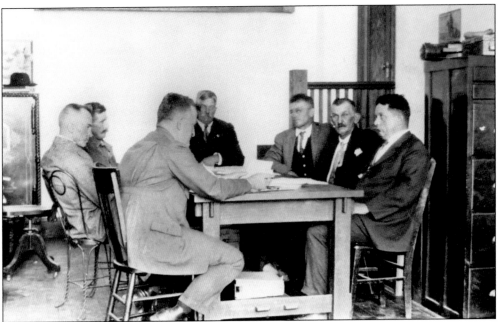

The first meeting of the board of directors of the Nevada Irrigation District was held on August 16, 1921. From left to right are Fred H. Tibbets, engineer; Carroll Searls, secretary; directors Theodore Swartz, Guy V. Robinson, William G. Ullrich, and Willis Green; and Munson Bernard "Bert" Church, president. A.L. Wisker (not pictured) was appointed manager at a salary of $1 per month. (NCRCD.)

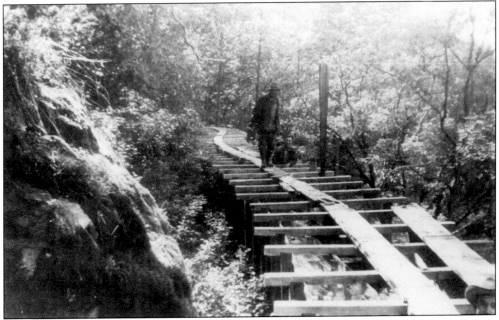

Louie Personeni, a ditch tender for the Nevada Irrigation District, is shown here walking on boards placed above the Excelsior Ditch on Owl Creek to check for any impediments blocking the flow of water. Tree branches, dead animals, and snow and ice were common causes of blockages. More serious problems could lead to a ditch breaking. (Linda Miller.)

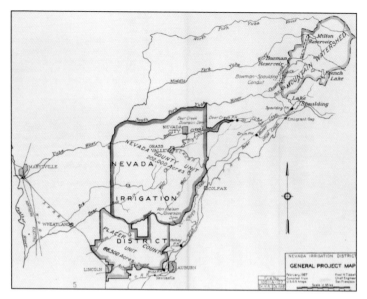

This 1927 map shows the area in Nevada County where agriculturists could obtain water from the Nevada Irrigation District (NID). As mining declined, the agriculture industry became the county's biggest consumer of water. In 1927, the district's annual audit showed that NID had invested over $6 million, and the Nevada County section contained 202,000 acres. (NCRCD.)

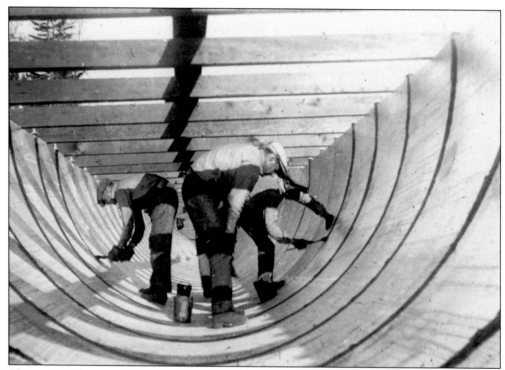

This c. 1927 photograph shows unidentified Nevada Irrigation District workers sealing the metal strips of the Lenon flume with an epoxy to prevent leakage. This flume is located just beyond Bear Valley and is part of the Bowman Spaulding system. The system diverts water from the Middle Yuba River at Milton Reservoir south into Bowman Lake. From there, a 13-mile conduit takes the water to Lake Spaulding. (NCRCD.)

Two

RENOWNED

HORTICULTURALIST

FELIX GILLET

Felix Gillet was born in 1835 in France. California and Nevada County owe much to the Nevada City pioneer nurseryman who opened the first nursery in Nevada County (it later became the second-oldest nursery in the state). Gillet was born into a family of nurserymen and introduced a soft-shell variety of walnut in 1879. The commercial walnut variety "Gillet" was named after him. During his lifetime, Gillet, one of the founders of the walnut industry in California, became the expert authority in the United States on nut trees and their propagation.

Gillet had a variety of interests, including bookbinding, and being a prolific writer, he sent letters and articles to newspapers and magazines about horticulture, astronomy, navigation and California Indians. In addition to working as a well-known horticulturist, he became a sericulturist—a producer of raw silk. Advertising in the local *Morning Transcript* in 1879, Gillet listed trees and plants of over 100 varieties, including walnuts, hazelnuts, chestnuts, medlars, prunes, figs, grapes, peaches, cherries, apples, grapes, currants, gooseberries, strawberries, and more. Gillet was a member of the Horticultural Board of Nevada County that was organized by 1881. Gillet died on January 27, 1908, and his wife, Julia Theresa, continued to operate the nursery until her death in 1913.

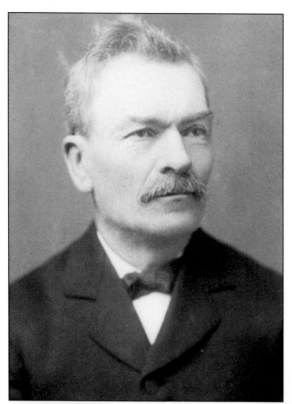

Most of the older walnut orchards of California, Oregon, and Washington were planted from stock distributed by Felix Gillet's nursery. Shortly after arriving in California in 1859, Gillet headed to Nevada City, rented a space in town, and opened a barbershop. (AC.)

After the great 1863 Nevada City fire, Felix Gillet relocated his barbershop to Commercial Street. He went to France for almost two years, and upon his return in February 1865, he reopened his shop on Pine Street. In 1871, he bought 20 acres of land and imported $3,000 of stock from France to start the Barren Hill Nursery in Nevada City. (AC.)

This is a postcard Felix Gillet gave out to his friends and customers in the early 1900s. Gillet published his own extensive nursery catalog, and he advertised throughout California and the Pacific Northwest. (DFL.)

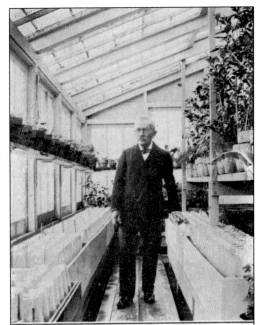

FELIX GILLET, Proprietor Barren Hill Nursery, Nevada City, California
Grafting in Greenhouse, 1-Year Old Walnut Trees, by the Treyve Process

Showing grafted trees covered with tumblers six inches high.

With compliments of

Felix Gillet

The FELIX GILLET NURSERY

1871 1926-27

NEVADA CITY
CALIFORNIA

After Felix Gillet's death in 1908, his wife, Julia Theresa, ran the business until she died in 1913. C.E. Parsons soon purchased the nursery and changed the name from Barren Hill to the Felix Gillet Nursery. This is the front cover of the extensive 23-page catalog for 1926–1927. In 1968, the nursery was thought to be the oldest continuously operating nursery in California. (DFL.)

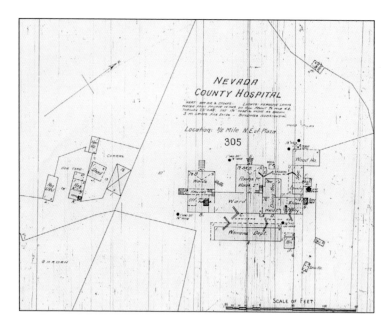

A page of the 1898 Sanborn Fire Insurance Map shows the Nevada County Hospital in Nevada City, where a large garden from Felix Gillet's stock provided vegetables for the residents. In July 1907, the county bought the 40-acre William Celio dairy ranch next to the hospital for raising cattle and to have fresh milk, butter, and eggs available. (DFL.)

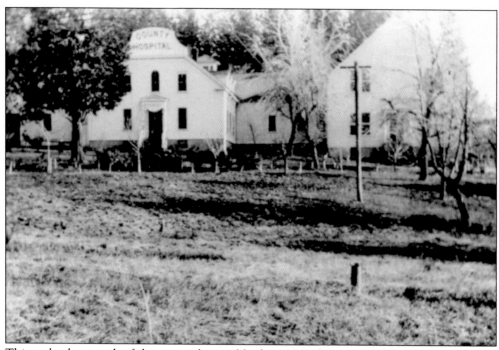

This early photograph of the county hospital built in 1860 shows part of the orchard that was probably from the stock of Felix Gillet's nursery. The hospital was a short distance from the old town plaza in Nevada City, and two wings were added later. (AC.)

Three

AGRICULTURE BOOM
NEVADA COUNTY
NARROW GAUGE RAILROAD

Prior to the Nevada County Narrow Gauge Railroad (NCNGR) becoming a reality, transportation to and from the two largest towns in the county, Grass Valley and Nevada City, was undertaken by stage, horse, buggy, and wagon. Merchants and mine owners had complained for decades about the robberies that took place just outside of Grass Valley on the narrow dirt road that led to Colfax. In 1869, the Central Pacific Railroad was completed, and Colfax was the nearest connection to the railroad. Talk began in earnest about the possibility of connecting Grass Valley and Nevada City to the railroad, as all Nevada County businessmen agreed that due to the high cost of transporting minerals, timber, produce, and other goods to the rest of the world, they would never be able to develop their business interests to a full extent without it.

On January 25, 1874, a meeting was held in Nevada City to discuss forming a policy for building a railroad without town, state, or county funds. A chairman was chosen and appointed 10 men each from Grass Valley and Nevada City to the committee. The committee consisted of the most prominent and important men in both towns. On the January 29, a second meeting was held to appoint six men (three from each town) to draft a bill to be presented to the state legislature. The bill was passed, and after many ups and downs, collecting subscriptions, putting down track, building bridges and a tunnel, changing the route, and dealing with stormy weather, the railroad was finally completed on May 20, 1876, over a distance of 22.5 miles from Colfax to the Nevada City depot. The railroad was in operation for 67 years, but due to the rise in popularity of the automobile and problems that plagued the railroad, the NCNGR ran its last engine on March 5, 1943.

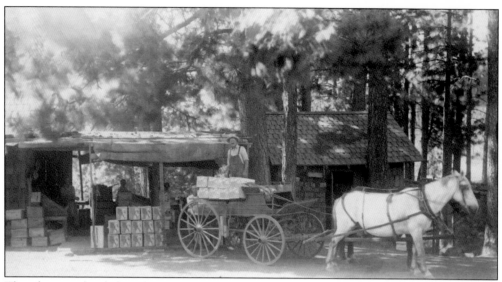

This photograph is believed to have been taken in Chicago Park, where a large tract of land was purchased and divided into lots. Several people are in the packing shed, and boxes of fruit are loaded in the wagon for delivery. (NCRCD.)

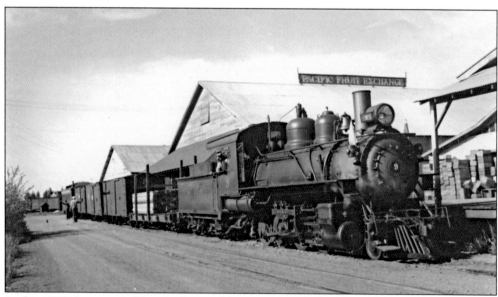

In this 1939 photograph, Nevada County Narrow Gauge Railroad engine No. 9 is on the track at Colfax. In the background are several fruit sheds; a sign above reads "Pacific Fruit Exchange" (PFE). Prior to the PDF, the fruit was shipped through the California Fruit Exchange that began in Newcastle in 1900. (AC.)

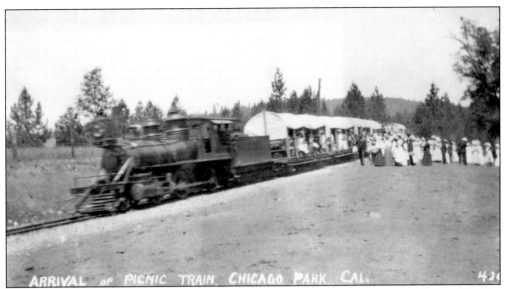

Beginning in 1902, the picnic train ran every Sunday from Nevada City, Grass Valley, and Colfax to Chicago Park and Shelby's pond. The round-trip fare was 50¢ for adults. The picnic train was very popular, and numerous groups held annual picnics in the summer and early fall, including the Miners' Picnic, Sunday school picnics, and the Annual Picnic of the Nevada County Farm Bureau. (DFL.)

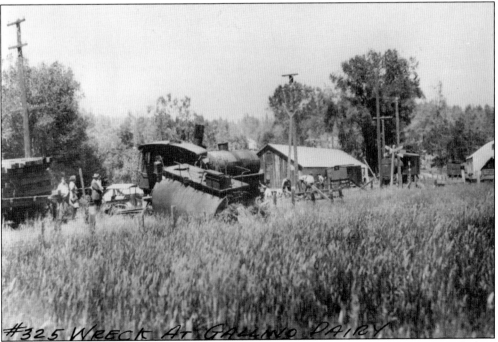

Nevada County Narrow Gauge Railroad (NCNGR) engine No. 7 was running backward when the train derailed at the Gallino Dairy outside of Grass Valley in June 1937. One of the worst disasters to befall the railroad occurred on October 6, 1940, when a fire destroyed the NCNGR's 50-year-old, two-story Grass Valley depot, freight warehouse, and the adjoining corrugated iron buildings of the Colfax Fruit Growers Association. (AC.)

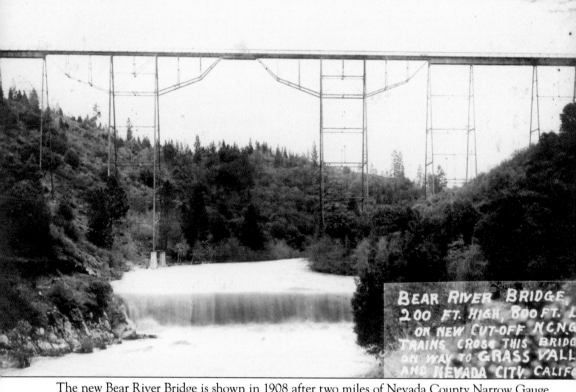

BEAR RIVER BRIDGE,
200 FT. HIGH, 800 FT. L
ON NEW CUT-OFF N.C.N.G
TRAINS CROSS THIS BRIDG
ON WAY TO GRASS VALL
AND NEVADA CITY. CALIFO

The new Bear River Bridge is shown in 1908 after two miles of Nevada County Narrow Gauge Railroad (NCNGR) track were removed to shorten the route. In 1925, it became apparent that only one-fifth of the freight coming into the county came over the railroad. Trucks were sapping the lifeblood of the railroad, and people formed the Citizens Railroad Committee and took out a full-page advertisement in *The Union* newspaper in which shippers, merchants, mine owners, and orchardists pledged to use the NCNGR for the transportation of all freight (except fresh vegetables other than onions and potatoes) to and from Nevada County. Some were concerned that if the railroad was abandoned, the prices of property would decline, and the highway leading in and out of the county would be subject to damage from heavy trucking and impossible to keep repaired. The railroad was able to survive for almost two more decades after the backing of the Citizens Railroad Committee, farmers, and merchants. (Browning family.)

Four

PROMOTION
BOOSTER ORGANIZATIONS

First-generation settlers sent letters back home telling of the advantages in California and describing the fine climate, natural resources, and the rich soil that could produce a wide variety of horticultural products. Prior to the Civil War, this alone was not enough to bring numbers of people to California that would make it a major agriculture producer. The years after the war would bring about different concerns alongside advances in agriculture and distribution.

In the late 1870s, Nevada County growers found themselves facing a new dilemma—competing with the growers of central California who were shipping fruit crops to Nevada and portions of Utah, Colorado, Montana, and Idaho Territory. Even through Nevada County growers were closer to those states and claimed that Nevada County produce was superior to what was grown in the valleys, the central California growers had the advantage in those markets because they had established regular agencies to introduce and sell their fruits and vegetables.

Editorials in *The Union* newspaper spelled out what was needed—cooperation among the fruit growers in Nevada County and an organized association. They needed an enterprise that would not only handle the packing and shipping of local produce but also establish a business to process the drying and or canning of fruits and vegetables. *The Union* warned that unless a few active men would take on this challenge, there would be valuable fruit going to waste and rotting on the ground.

In the meantime, the citizens of California were told in newspapers and promotional periodicals like the *Overland Monthly* that it was their duty to develop and bring to perfection the resources of the state to this favored land. One of the first local booster groups was the Nevada County Land and Improvement Association, believed to be formed in 1887. The goal of the association was to make the Nevada County area known to settlers, tourists, and health-seekers by printing and sending out pamphlets throughout the United States, Canada, and some European countries.

This photograph shows the front cover of a small pull-out booklet published by the Nevada County Promotion Committee. Although it is not dated, it was printed after 1907 (when the Nevada City Library opened), since the library is illustrated on one of the pages of the booklet. (Bierwagen family.)

In 1913, Nevada County's exhibit at the California Home Land Show and Home Industry Exhibition in San Francisco won the first prize of the show and eight other first-place ribbons, two second-place ribbons, and one third-place ribbons. The booth was arranged and entered by the Grass Valley Chamber of Commerce. The pergola was made of cedar logs and decorated with golden lights, leaves, and boxes of fruit and nuts. (AC.)

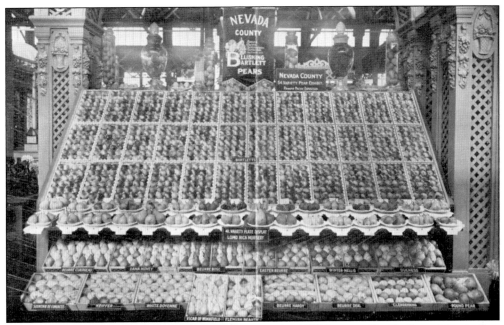

This Nevada County exhibit won the grand prize at the 1915 Panama-Pacific Exposition in San Francisco. The county's famous Blushing Bartlett Pear and 54 other varieties of pears were featured in the exhibit. More than 18 million people visited the fair in 1915; it covered 600 acres along two and a half miles of waterfront property that highlighted San Francisco's grandeur. (AC.)

This undated pamphlet issued by the Nevada County Development Association folded down the middle and showed Nevada County's gold rush history on the left and the rich agriculture scene on the right. It was published after 1915, since it contains the photograph of Nevada County's exhibit from that year's Panama-Pacific Exposition. (AC.)

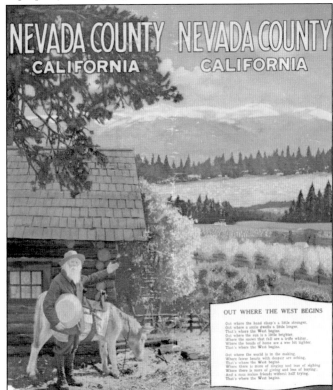

Nevada County,

THE FAMOUS

BARTLETT ✦ PEAR ✦ BELT

OF

CALIFORNIA.

Its Horticultural Resources, Healthfulness of Climate, Temperature, Rainfall, Topography, Facilities for Irrigation, Large and Profitable Yield of Fruits, and other Useful Information for Home-Seekers.

FERTILE LANDS AT LOW PRICES! ABUNDANT HARVESTS!
LARGE PROFITS!

Edited and Compiled by E. M. PRESTON.

PUBLISHED BY THE
NEVADA COUNTY LAND AND IMPROVEMENT ASSOCIATION.
Copies will be sent free, on application to G. E. BRAND, Secretary, Nevada City, Cal.

Nevada City:
BROWN & CALKINS, PRINTERS NEVADA DAILY TRANSCRIPT.
1886.

This is the title page of the rare 96-page booklet published by the Nevada County Land and Improvement Association to promote and describe the rich resources of the county—especially "The Famous Bartlett Pear Belt of California." (AC.)

This 1886 pamphlet carried both local and out-of-town advertising and articles about various aspects of Nevada County and its amenities and descriptions of its land and resources. The old Celio horse barn on Sacramento Street was one of Nevada City's most historic buildings. When William Celio first came to Nevada City as a young man, he went to work for G. Ramelli. (AC.)

G. RAMELLI,

MILK DAIRY,

⊱·NEVADA CITY.·⊰

Largest Milk Dairy in Nevada County.

MILK FURNISHED BY THE

PINT, QUART OR GALLON

At Lowest Market Prices.

MOUNTAIN FARM MILK DAIRY,
—OF—
WILLIAM CELIO.

Pure Milk Furnished by the Pint, Quart or Gallon
—AT LOW PRICES.—

Orders left at P. Gunther's, Commercial Street, will receive prompt attention.

Five

CHICKENS GALORE
ON RANCHES AND FARMS

By the beginning of 1881, a horticultural board had been established in the county and consisted of Felix Gillet, Charles Barker, and Henry Hatch. The board gave warnings to fruit growers about the dreaded codling moth along with instructions on how to treat trees. This pest had caused extensive damage to orchards in nearby counties and could ruin both the apple and pear crops if they were found in Nevada County. Farms and ranches were widely established throughout western Nevada County by the mid-1880s.

In the fall of 1888, a new 96-page booklet was published by the Nevada County Land and Improvement Association to promote and describe the rich resources of the county—especially "The Famous Bartlett Pear Belt of California." The booklet placed a strong emphasis on growing fruit, for it was claimed that there was no superior place and that every variety of fruit would grow and flourish. The county contained farms and ranches where fruit and vegetables were grown without irrigation, should a drought be experienced, due to the abundance of water stored in reservoirs from snow melt and water available in old mining ditches to supply farmers year-round.

The next two decades featured the highest rates of immigration to the United States in history. To take advantage of immigrants looking for new homes, marketing was produced locally by the state and the railroads wanting to expand business in the West. The posters and advertising material were colorfully illustrated and showed the fertile hills and valleys and pictures of the plentiful produce grown in California. This advertising emphasized cheap land and a better lifestyle than living in the crowded cities back east; again, the call was to "go west, young man," where there was land available—making land California's new gold rush.

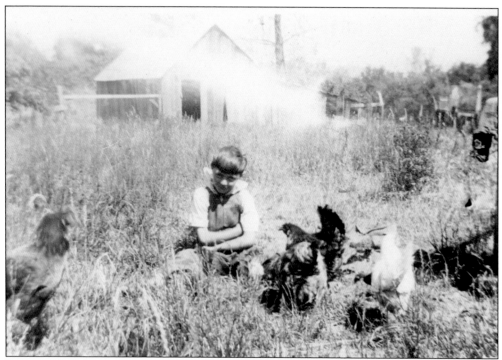

Every ranch or farm raised chickens, even if only for use by their own family. Donald Melvin Gates is pictured here in 1930 at around age 10 with his chickens. Gates was the stepson of Guy Vana Robinson and grew up on the Robinson ranch; he was a rancher all his life. He married Frances Personeni and was a 50-year member of the Farm Bureau. (Robinson family.)

This photograph shows the one remaining coop of Robert McWhinney's 570-acre chicken ranch that started in 1954 on Indian Springs Road. It was said to be the most modern in the entire state and had highly modern machinery; chickens were automatically fed and watered, and eggs were moved by a conveyor belt. The laying hens were cage-nested, and the eggs were automatically washed, cleaned, and graded before being cased for Nulaid Farms. (Ray McWhinney.)

The Rolph family purchased a ranch in Chicago Park in 1914. Edythe Rolph's parents, Elias and Eliza Parker, crossed the plains in 1864 to come to California. Shown in this 1915 photograph is Fern Rolph, daughter of Edythe and Carl Rolph, working on the family ranch where she lived all her life. They raised cattle, sheep, and chickens and had a large fruit orchard. (Moberg family.)

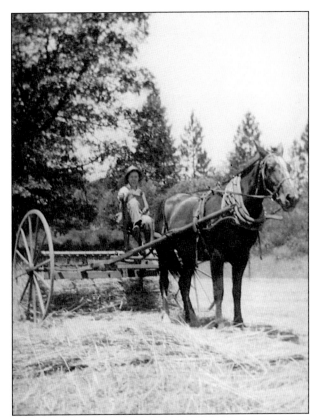

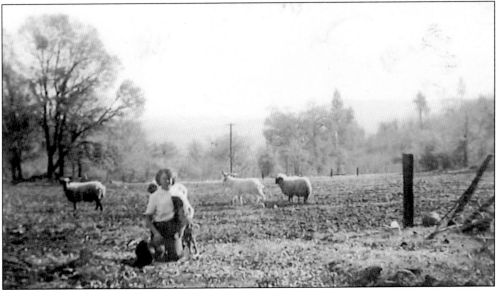

Darlene Moberg lived next door to her grandparents, Edythe and Carl Rolph, and her aunt, Fern Rolph. From the 1920s through the 1950s, the Rolph ranch had 2,000 to 5,000 laying hens. Edythe's job was to take care of the 1,000 baby chicks, while Fern took care of the hens. This 1980s photograph shows Darlene Moberg and her sheep, with some weighing between 160 and 300 pounds. (Moberg family.)

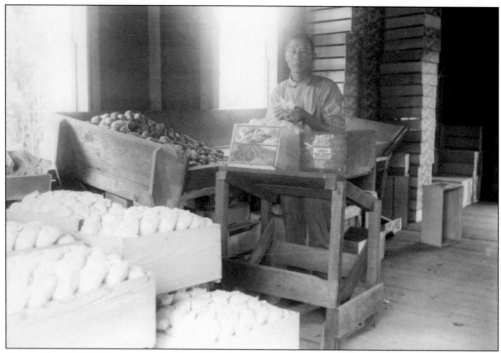

An unidentified Chinese man is individually wrapping pears with special tissue before packing them in wooden crates. Pears were often called the "Queen of Fruit" because they had to be handled with care. Pears have delicate skin that is very susceptible to bruising and abrasion by stiff stems bumping against another piece of fruit. (NCRCD.)

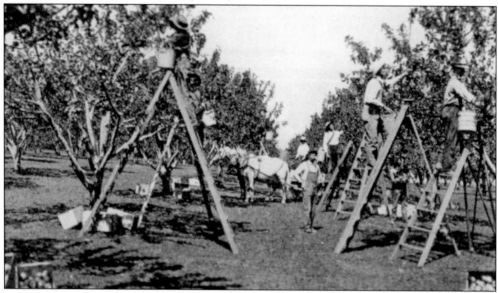

In 1913, the Nevada County Cannery Association was formed and found a site on which to build on Railroad Avenue in Grass Valley between the lines of the electric trolley and the Nevada County Narrow Gauge Railroad. Area farmers were reaping unprecedented horticultural crops, and it had been a long-awaited goal to the have a cannery in the county. This undated photograph shows workers picking fruit. (NCRCD.)

The new cannery was finished and a reception was held on June 19, 1913, when the cannery was opened to the public for the first time. Cherries were the first type of fruit canned there. Following the creation of the cannery, area growers could be assured that there would be no wasted fruit in overabundant crop years. This photograph shows wooden boxes lined up and ready for pickers to begin picking. (NCRCD.)

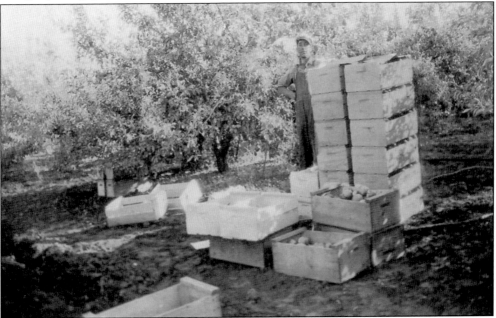

In the fall of 1889, fruit growers in some sections of the county had an off year due to fickle weather. Fruit was damaged by frost, some was disfigured by hail, and some was infested by the codling moth. Snow, hail, and heavy rain during the growing season was disastrous to fruit and other crops. In this undated photograph, a worker is picking and packing fruit. (NCRCD.)

Fruit box labels featured very colorful graphics, as growers wanted the public to identify them with their particular brand of fruit. They had to compete with other fruit varieties as well as hundreds of other growers for attention. The Colfax Fruit Growers Association shipped fruit grown locally, mainly from Grass Valley, Peardale, Chicago Park, and Colfax. The boxes were transported on the Nevada County Narrow Gauge Railroad to the fruit sheds at Colfax and packed for shipment in boxcars and shipped as far east as New York and into Canada. (Bierwagen family.)

Six

Grass Valley
Bierwagen and Gallino

In 1855, the Nevada County Board of Supervisors created seven townships: Nevada, Grass Valley, Rough and Ready, Bridgeport, Eureka, Little York, and Washington. In 1858, Bloomfield was created from part of Eureka, and in 1866, Meadow Lake was created from part of Washington. Within the townships were towns, communities, sections, flats, and valleys with distinctive names. The Bierwagen family settled in Chicago Park, an agricultural community located nine miles southeast of the City of Grass Valley.

The first local mention of a party of Chicago colonists was on July 8, 1887, in *The Union*, which reported that a large tract of land had been purchased through a Colfax real estate agent and the property was to be divided into 10- and 20-acre ranches. Eighty acres of land had been set aside for a townsite out of the 6,700 acres purchased, and the townsite was named Chicago Park. Charles Stafford was the director of the Chicago-California Colonization Company, which was formed in Chicago in February 1886. On September 19, 1887, a drawing was held in Chicago for lots in the colony. Half-lots were sold to merchants and tradesmen, and land was set aside for a 14-acre park; a large hotel was planned but never built.

By the time Antone Gallino arrived from Italy in Nevada City in 1913 to mine, it had been a thriving town since the Gold Rush. Gallino's fourth child, Frank, was the first child to be born in California on October 4, 1915. In 1915, Antone moved his family to a ranch along Allison Ranch Road in Grass Valley while he worked at the North Star Mine. He then purchased a 50-acre parcel known as the old Geach place at Hills Flat in Grass Valley. He worked the land, planted a large garden, and began the Gallino Diary with one cow. While expanding the herd, he delivered milk to homes and businesses by horse and buggy. Today, descendants of Bierwagen and Gallino continue the legacy of farming and ranching in Grass Valley Township.

Pioneers Johann Ludwig and Anna Elizabeth Triebwasser Bierwagen immigrated from Russia in 1881 and farmed in South Dakota before moving to Chicago Park in 1902. Elizabeth bore 13 children, and 10 survived. Ludwig died on April 17, 1903. Christian, their 11th child, bought adjoining farmland next to the original homestead. (Bierwagen family.)

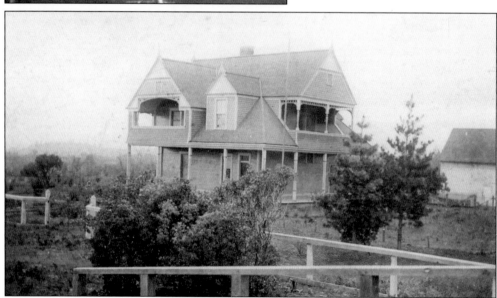

The old Bierwagen home was one of the earliest residences built in Chicago Park; it was originally built for Mabel Briot around 1885 by her husband, Charles H. Briot, who was in the real estate and lumber businesses. Ludwig Bierwagen paid $4,250 in gold coin for the property, including the house and numerous outbuildings. (Bierwagen family.)

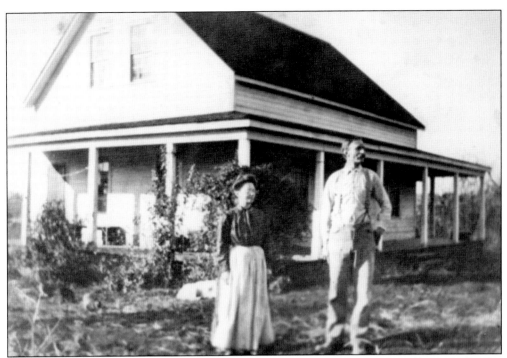

Standing in front of their home in Chicago Park are Christian Bierwagen and his wife, Bertha Araminta Sternitzky. They were the parents of two children, Ernest (Ernie) Bierwagen and Dorothy Elizabeth Bierwagen (Tangern). In 1914, Christian Bierwagen invited all the landowners (and their families and friends) in his subdivision to a picnic. At this gathering, a farm club was formed, and members new to farming could discuss their problems. (Bierwagen family.)

Pictured standing from left to right are Bertha Bierwagen, Christian Bierwagen, and Wilhelmine "Minnie" Bierwagen Merkle and her husband, Carl Merkle. Minnie and Carl married in 1904. In 1908, Carl bought from Christian Bierwagen the 20 acres on which the original Mabel Briot house stood. The two women seated in the front are unidentified. (Bierwagen family.)

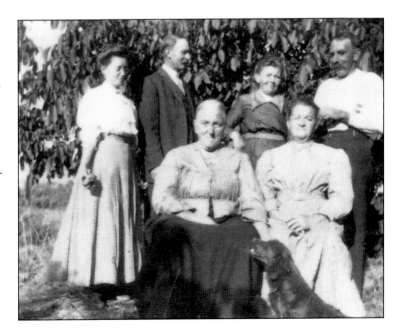

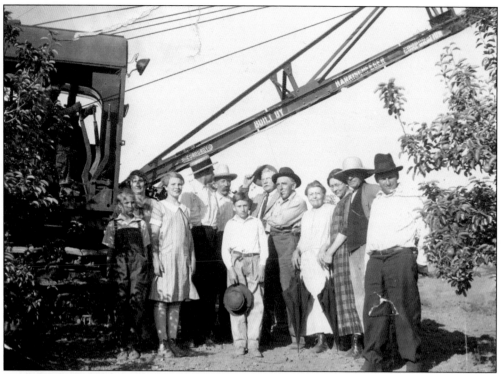

In the 1920s the Bierwagen and Merkle family dug a ditch for Nevada Irrigation Ditch water. Shown in the photograph are Ruby Meyer, Archie Felden, John F. Siems, Carl Merkle, Minnie Merkle, Elizabeth Bierwagen, ? Kelpin, and Hans Kelpin. Minnie and Carl Merkle are fourth and fifth from the right, respectively. (Bierwagen family.)

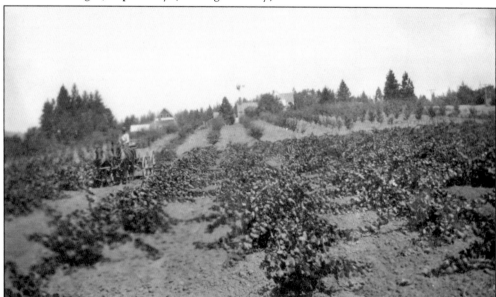

Ludwig Bierwagen is believed to be the man riding behind the horses in the wagon in this c. 1900 photograph showing part of his farm and orchards where grapes and plums were grown at the time. (Bierwagen family.)

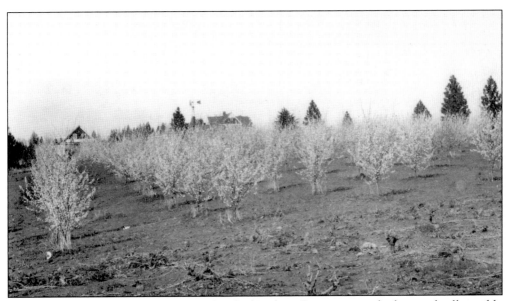

This 1900s image shows the plum orchard of Ludwig Bierwagen with the windmills visible in the center background. When Bierwagen died in April 1903, he was the first person to be buried in the new German Lutheran Cemetery that had just been completed in Chicago Park. (Bierwagen family.)

During the Depression, no one had money to buy produce, but the economy turned during World War II. The Bierwagens switched from pears to apples and experimented with peaches in the 1960s. Ernie Bierwagen (shown in this undated photograph) was elected to the board of directors for District II of the Nevada Irrigation District in November 1977, and his opponent said that if he was not running, he would have voted for Bierwagen. (Bierwagen family.)

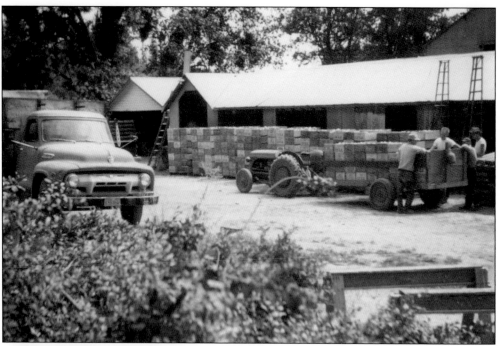

Boxes of Golden Delicious apples are ready for market in this 1960s photograph. Two varieties of apples are used to create the raw unfiltered cider that the Bierwagens have been making and selling for 45 years by using an old-fashioned rack and cloth press. Today, Chris Bierwagen uses five tons of hydraulic pressure on the mash; it takes three boxes of apples to make six to eight gallons of cider. (Bierwagen family.)

Kevin Pharis is shown moving buckets of peaches that are ready for sorting and packing at the Bierwagen farm in 1992. Pears were the main crop for 60 years until the late 1950s or early 1960s, when local farms were hit by the pear decline and blight. Nevada County was famous for their Bartlett pears, and in 1950, Nevada County ranked 27th in pear production in a list of the 100 leading agriculture counties of the United States. (Bierwagen family.)

Peaches and apples grow well in Nevada County's rich foothill soil. Packing peaches in one of the Bierwagen packing sheds in this 1990s photograph are, from left to right, Debbie Bierwagen, Ben Goodwin, Mary Betancourt, Danny Bierwagen, Kevin Pharis, and Tabitha Peterson. (Bierwagen family.)

Ernie Bierwagen, front left, is shown loading pears in 1953. He started each day by going outside and grabbing a handful of soil. He let it run through his fingers, sniffed it, and sometimes even put a little pinch on his tongue. He would then gauge the temperature, humidity, and wind direction—everything that would give him a clue as to what Mother Nature had in store for the next 24 hours. (Bierwagen family.)

In this 1997 photograph, Ernie Bierwagen is standing among boxes packed with peaches. In May 1963, Bierwagen woke up to a blanket of snow covering the orchard. The pink blossoms were covered, and it was freezing, and the whole crop was lost. Apples were less susceptible to cold spring weather, and Bierwagen also decided to plant late harvest peaches after the crop loss. (Bierwagen family.)

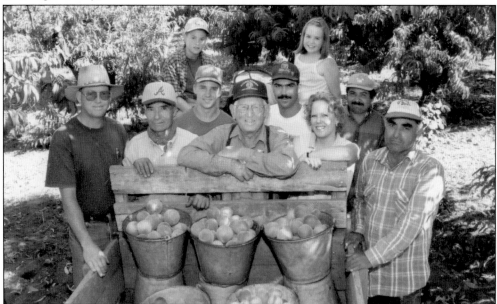

In 1974, the Happy Apple Kitchen opened so that folks could buy fresh fruit right off the tree—and pies. This c. 1990 image features a peach-picking crew. From left to right are (first row) Chris Bierwagen, Angel Betancourt, Ernie Bierwagen, Debbie Bierwagen, and an unidentified Betancourt; (second row) Kevin Pharis, Gault Strong, and Javier Betancourt; (third row) Danny Bierwagen and Rosie Bierwagen. (Bierwagen family.)

Antone Gallino (pictured here in his wedding portrait) brought his bride, Margarita, to the United States after their marriage in 1909. After first going to Michigan and then Kimberly, Nevada, they settled in Nevada County in 1913. Gallino worked in several mines and lived in Nevada City before moving to a ranch along Allison Ranch Road in Grass Valley and working at the North Star Mine. (Gallino family.)

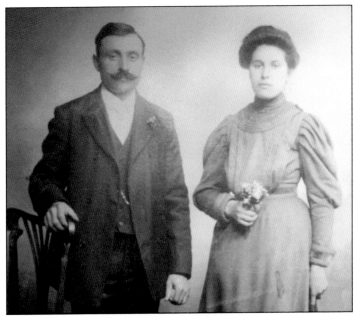

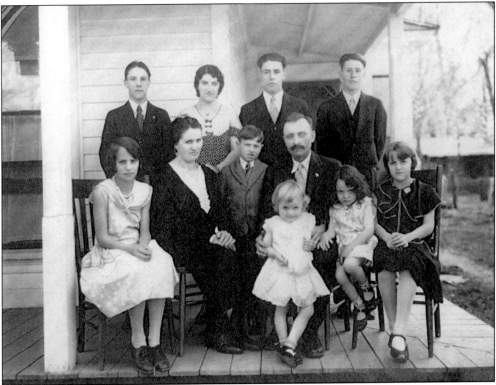

In 1915, the Gallino family purchased the old Geach place, a 50-acre parcel at Hills Flat. Antone Gallino worked the land, planted a garden, and began a dairy with one cow. This family portrait taken sometime before Cecilia Gallino was born in 1932 shows, from left to right, (first row) Kathryn, Margarita, William, Antone, Jeanette, Norma, and Margaret Gallino; (second row) John, Katherine, Manuel, and Frank Gallino. (Gallino family.)

This photograph shows an overview of the Gallino Ranch and Dairy property; today, this location is home to Gold and Green Rentals and Hills Flat Lumber. The land where their house sat is now the middle of the Golden Center Freeway near the Idaho-Maryland off-ramp, and the house and barns were torn down in 1960. After Antone's death in 1938, his son Manuel took over the management of the dairy. (Gallino family.)

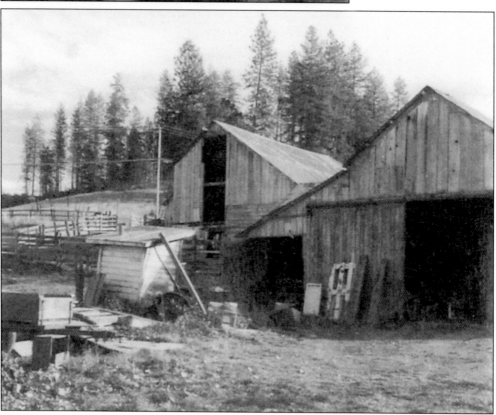

The dairy was successful and kept the Gallino family busy with everyone working in the business or at home. Every morning, each child had to do chores before going to school. This left the family without much time to make social calls. Instead, friends and family came to play and visit—the dairy was a social hub. This image shows the old Gallino barns. (Gallino family.)

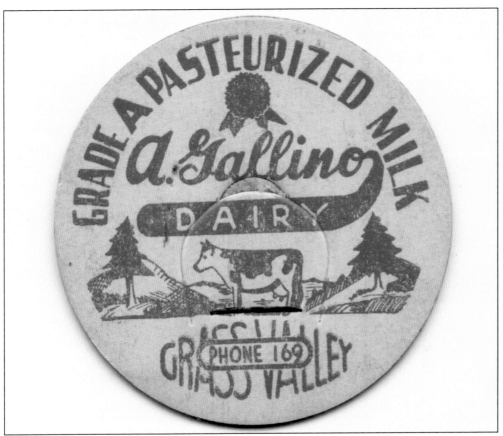

The Gallino family delivered milk around town in a horse and buggy in the early days of the dairy, then delivered by truck until about 1943. Paper milk cartons had come out during World War II, and the Gallino family could not get a machine to make the cartons, but no one wanted glass bottles any longer. An original cardboard cap from the Gallino Dairy is shown here. (Gallino family.)

In the 1940s, the Gallino family gave up their local milk route and contracted with several large distribution companies to sell their milk to Borden, Foremost, Golden State, and Crystal Dairy. By then, the Gallino Dairy was a Grade A dairy because they used refrigeration to keep the milk cold. This advertisement appeared in the *Morning Union* in 1923. (Gallino family.)

Gallino Dairy

Offers fresh dairy products, delivered twice daily by prompt motor service.

Gallino Dairy products are from T. B. tested herds, pastured on irrigated lands.

Gallino Dairy products are rich in food value and pure to highest degree. Complete refrigeration system and regular state inspection insure wholesome products.

TELEPHONE 169

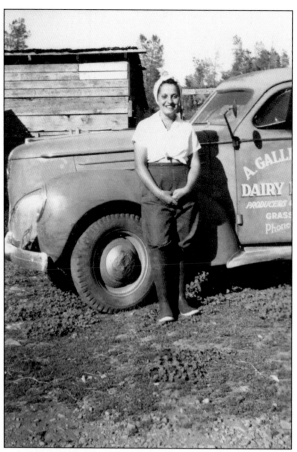

In this 1940s photograph, Norma Gallino poses in front of a Gallino Dairy truck in her tall rubber work boots. Norma was born in 1926 in Grass Valley and worked at *The Union* newspaper for many years when it was on Mill Street. (Gallino family.)

This c. 1939 photograph includes the 10 Gallino children. From left to right, they are (first row) Frank, Manuel, Angelina, John, and William (Bill); (second row) Jeannette, Katherine (Kay), Norma, Margaret (Midge), and Cecilia (Cece). Frank became one of Nevada County's best-loved native sons. After returning from World War II, Frank served as a deputy and then as undersheriff. (Gallino family.)

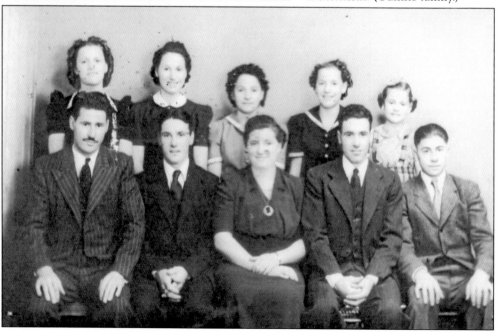

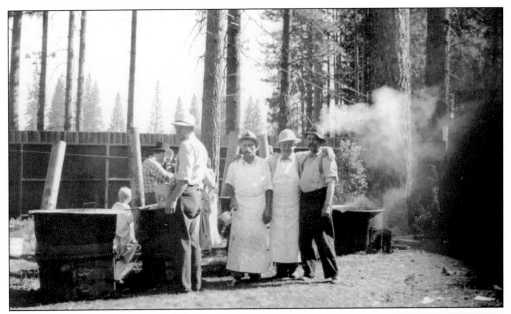

The Sportsman Club Camp and Dove Stews have been an institution in Nevada County since the 1890s. In August 1935, a meeting was held at the Gallino home and those present determined that a venison camp stew would be held that year on Sunday, September 22, at the Casey Ranch headquarters. This photograph shows Antone Gallino (second from left) preparing for a camp stew in the early 1930s. (Gallino family.)

Manuel Gallino is leading a Guernsey bull while his father, Antone, looks on. The dairy had 50 cows and 3 milking machines. After they sold off the milk cows, the ranch continued to raise beef cattle. After his father's death, Manuel helped his mother raise his younger sisters and brothers and also worked as a ditch tender for the Nevada Irrigation District until he retired in 1984. (Gallino family.)

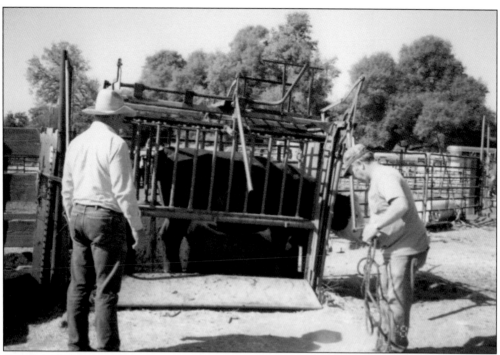

A cow in the squeeze chute is being doctored at the Gallino ranch in this undated photograph. Besides a lot of hard work, ranchers and farmers had to have a tremendous amount of knowledge about land, weather, and the animals they raised. (Gallino family.)

The three Galliano family dogs shown here are Guido, Giuseppe, and Rosa. Part of their job was to keep the livestock in a group and push the animals forward in the direction their masters wanted them to go. The dogs would generally stay behind the livestock and also served as an alarm when danger or a stranger appeared on the property. (Gallino family.)

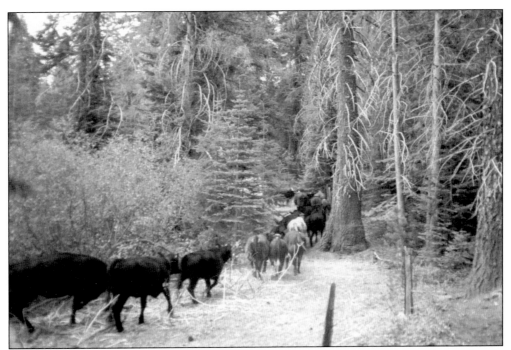

These Gallino cows have reached high country and are following the trail to pasture and water. Many ranch families owned their own land in the high country, where they had cabins and other amenities to make life more comfortable for the season. (Gallino family.)

A young David Gallino is shown in the early 1950s at the Gallino ranch, where he grew up. The ranch had acres to run around and play, sheds, warehouses, a chicken coop, a big garden, fields and pastures, and the Nevada County Narrow Gauge Railroad running right by the property. (Gallino family.)

David (Dave) Gallino and his wife, Barbara, are the fourth generation of the Gallino family of ranchers in Grass Valley and own and mange the 160-acre ranch today. This photograph shows Dave when he was in his teens with his dog, Doc, who Dave said was the smartest dog he ever had. (Gallino family.)

David Gallino is shown checking out the cattle chute for possible repairs. David had two older brothers, Ron and Don, but he is the only one of his immediate family in the area who is still involved in agriculture, except a cousin in Nevada City. (Gallino family.)

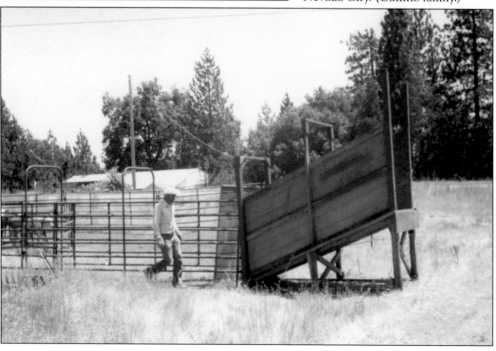

Seven

NEVADA CITY
ARBOGAST AND PERSONENI

In 1848, a few men ventured high into the Sierra Nevada foothills to search for gold. By 1850, between 6,000 and 16,000 miners were living in Nevada City, making it the third-largest town in California (behind San Francisco and Sacramento). With more voting power than Grass Valley or Rough and Ready, it became the county seat in 1851. It is located in the center of the western part of the county, and many other towns and communities developed around it. John Peter Arbogast was descended from early German pioneers who first settled in Maryland in 1751 then moved to Pennsylvania. After arriving in the Nevada County area in 1852, he wrote to his brother Jacob telling him to come to California. Four years later, Jacob's wife and his four children left Pennsylvania accompanied by other family and arrived in Nevada City, then located to the area known as Blue Tent.

The Personeni family settled in the area of Newtown, west of Nevada City. Andrew Personeni arrived from Italy in 1906 and lived in Michigan for one year. He then moved to California and settled in Nevada City. Around 1911, he purchased a piece of land on the McKittrick Ranch road that became the family ranch. In 1914, his wife, Maria, and their two sons, Phillip and Louis, arrived in California. Like most of the early ranchers, Andrew Personeni worked other jobs to earn money while we was planting crops and raising livestock. No matter what their occupations were, most locals at the time worked in mining or had a mining interest.

Pioneer John Peter Arbogast was the first of his family to arrive in California in 1852. When he arrived, he purchased the L.W. Scott ranch in the area around Rock Creek that was known as Blue Tent or Selby Flat and located five miles above Nevada City. In 1860, he wrote to his brother Jacob Peter Arbogast to join him in California. (Davies family.)

The Arbogast Ranch had four mines on the property: Western Merger, Davis, Randolph, and the Round Mountain mine for which the family had a 99-year lease. The original house burned down in 1928. In 1918, Andora Cox Davies renamed the ranch as the Dipper Valley Ranch because on a clear night you could see at least one of the Dipper constellations. (Davies family.)

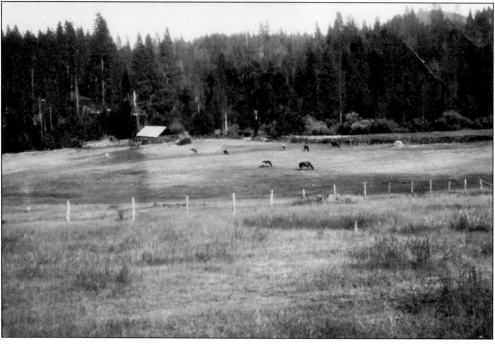

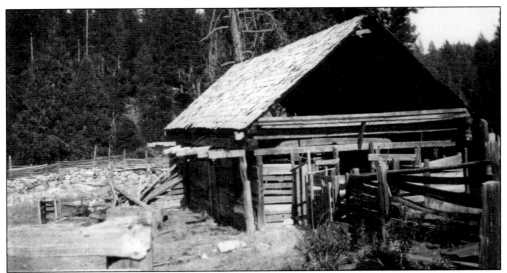

This old barn was originally called the "sod house" and may have been one of the earliest structures built on the Davies/Davis property besides one or more cabins. In addition to working the four mines, the family raised cattle, had a dairy, and logged and owned the Cooper Sawmill. There was enough work to keep every member of the family busy just about every season. (Davies family.)

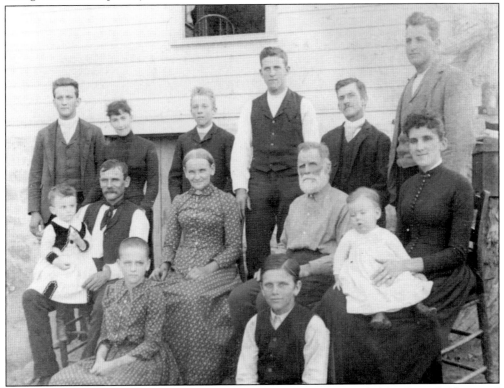

Pioneers Jacob Peter Arbogast and his wife, Eliza 1887, are surrounded by their children and grandchildren at their ranch. Pictured here from left to right are (first row) Elsie and Cary; (second row) Peter (holding his son Kenneth), Elizabeth, Jacob Peter, and Keturah (holding her son William) (third row) Fred, Deed (Peter's wife), Aaron, Perry, Jonathan, and Jacob. (Davies family.)

This is the 1888 wedding portrait of Eliza Keturah Arbogast and William Benjamin Davies. William was a miner and the mine superintendent of the Texas Mine in Willow Valley before his death at age 39. The couple had five children: William Leroy, Arthur W., Harry M., Gilbert J., and Thomas A. After her husband's death, Eliza's son Harry managed the 150-acre ranch. (Davies family.)

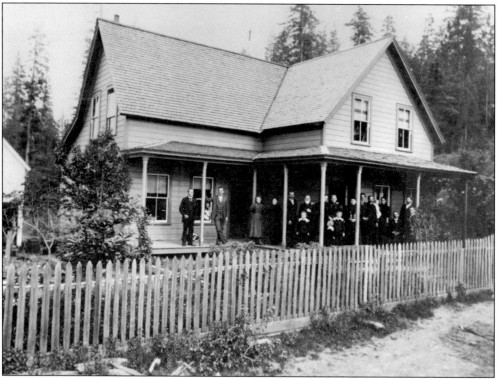

This undated photograph was taken around 1890 on the porch of the Arbogast home in Blue Tent. Pioneer Jacob Peter Arbogast acquired mining claims of 160 acres and added 80 acres to the family ranch. His first wife, Catherine Shrawner, died in 1857. Four of his children were born in Pennsylvania, and eight more were born in California. (Davies family.)

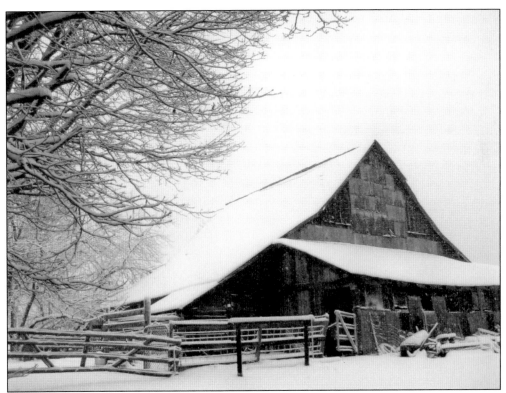

A snowy scene shows the old Arbogast barn that was taken apart at North Bloomfield and moved to the mine site. In the beginning, the Arbogast family lived in a small cabin. Two family homes were later built on the property. Eliza left the ranch to her youngest son, Cary Arbogast. He later sold it to William Davies. (Davies family.)

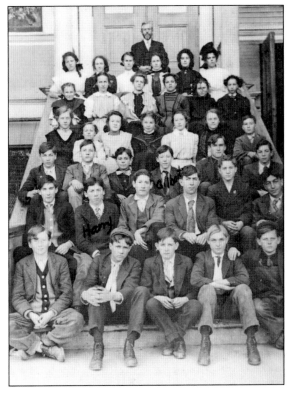

This 1906 school photograph shows Harry Arbogast (second from left in the second row) and his brother Gilbert (fourth from left in the third row). Harry became a rancher and miner. Gilbert became a teacher at the Washington and North San Juan School District and taught at Blue Tent, and in 1921, he was the principal of Nevada City Grammar School. (Davies family.)

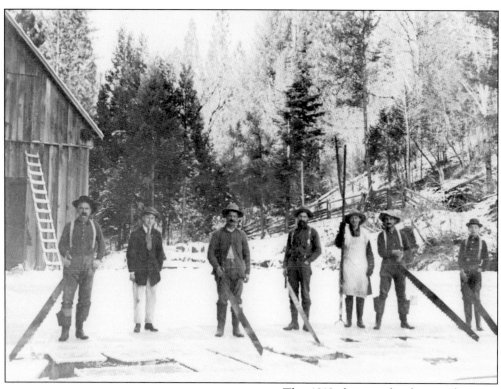

This 1910 photograph taken on the Arbogast property shows men with long saws cutting ice between the two ranches. From left to right are John P. Arbogast, Albert Benson, Louis Brindenjohn, Dan C. Campbell, Theodore Nelson, Kenneth Arbogast, and Ramah P. Arbogast. Ice-cutting was an important industry before refrigeration. The ice industry in Eastern Nevada County provided many jobs in the area. (Davies family.)

William Davies (left) stands next to his younger brother Harry on the ranch around 1900. William was born at the Derbec mine above Malakoff Diggins in North Bloomfield on September 24, 1889. This was the year of the "big snow," and William's mother, Eliza, said that they could see people walking by on the eaves of their roofs. (Davies family.)

Harry Davies (left) and his brother Tom pose in front of one of the mine entrances at the Arbogast ranch in this c. 1920 photograph. In 1905, their mother, Eliza, had an opportunity to manage a rental property in San Francisco. She was living there when the 1906 earthquake struck San Francisco. Eliza's brother, Nevada County clerk Fred L. Arbogast, went to rescue his two sisters and his nephews. (Davies family.)

William (left) and Harry Arbogast are laying water pipe at the Dipper Valley Ranch in this undated photograph. William was not only a teacher and school principal but also a member of the Nevada County Board of Education. He was actively involved in advancing education in Nevada County. (Davies family.)

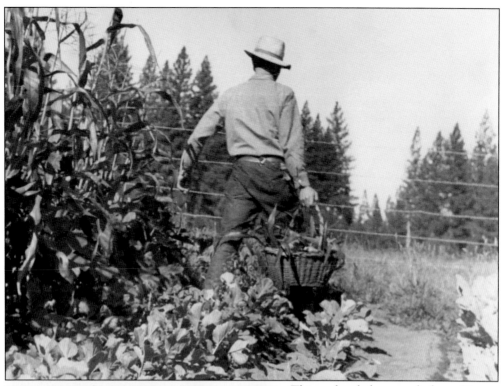

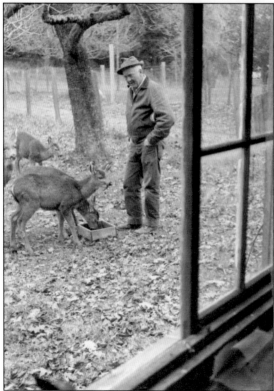

This undated photograph shows Harry Davis picking fresh vegetables from his garden. He did not like the Davies name and dropped the 'e,' becoming Davis. Jacob and Eliza Arbogast's descendants became farmers, gold miners, doctors, dairymen, and cattle ranchers and owned sawmills, ran boardinghouses, served in the military, were educators, and participated in local government. (Davies family.)

Although Harry Davis did not want the deer to eat his vegetables, he was fond of the creatures and gave them special treats. Although Harry dropped the "e" from his name to become Harry Davis, his other brothers still used the Davies surname. (Davies family.)

Andrea (Andrew) Personeni arrived in America in 1906 and worked in a copper mine in Michigan. He moved to Nevada City and worked in the gold-mining industry until he was able to buy land. In this 1918 photograph are, from left to right, (first row) Maria (holding Mario), John, and Andrea; (second row) Phil and Louis. Andrea and Maria's youngest son, Lawrence, was not yet born. (Miller family.)

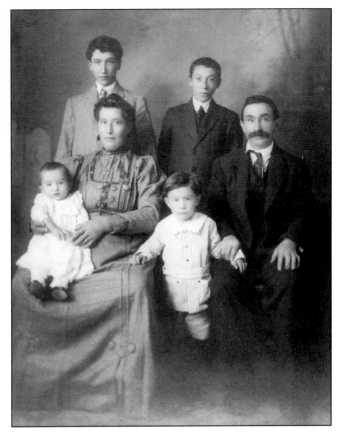

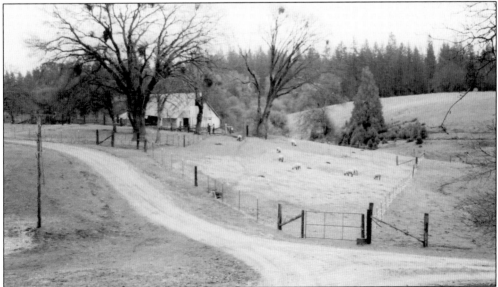

The Personeni ranch property was located in the Newtown district. Andrea Personeni (who also went by Andrew) purchased two parcels of land. He acquired his first piece of land in Nevada County on July 19, 1910, after purchasing it from J.L. Burks. Andrew's wife, Maria, and his sons Phil and Louis arrived in the United States in 1913. (Miller family.)

Phil Personeni arrived in Nevada County on January 4, 1914, with his mother, Maria, and his brother Louis. He and Louis attended the one-room school at Newtown, walking the six-mile trip each day. In 1918, he worked for the Excelsior Water and Power Company, the forerunner of the Nevada Irrigation Ditch. Working the winter months, he helped on the family ranch in the summer. (Miller family.)

Johanna Hosle immigrated from Germany to the United States in 1924, when she was 18 years old and spoke no English. She came with a letter from her aunt, Martina Beck, to guide her; Martina lived in Rough and Ready. Johanna worked for the Foote family at the North Star house. She married Phil Personeni in 1926. They began their married life operating a dairy at the Williams Ranch. (Miller family.)

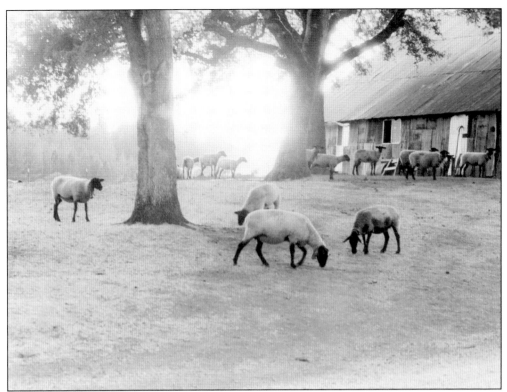

In 1929, Phil and Johanna Personeni purchased a ranch on Bitney Springs Road. They had four children: Andrew, Philip, Frances, and Linda. The family worked hard on their ranch, where they raised cattle and sheep. Johanna worked alongside her husband and brothers-in-law to clear the land using a team of horses. Johanna sewed at night to bring in extra money. (Miller family.)

In 1952, Maria and Andrew Personeni celebrated their 50th wedding anniversary. Standing behind them are their five sons (from left to right): Phil, Louis, John, Mario, and Lawrence. Andrew made most of the equipment used on the ranch in his old blacksmith shop, and in 1928, he built a new ranch house and put in a ditch from the Newton reservoir to bring water to the ranch. (Miller family.)

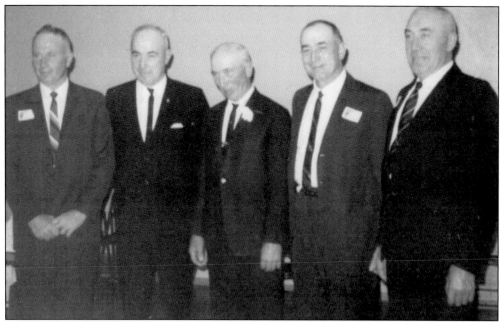

In 1969, Phil Personeni was honored by the Nevada County Historical Society as Citizen of the Year. He is pictured at that event with his four brothers; from left to right are Lawrence, John, Phil, Mario, and Louis. John, Mario, and Lawrence all served in the Army in World War II. (Miller family.)

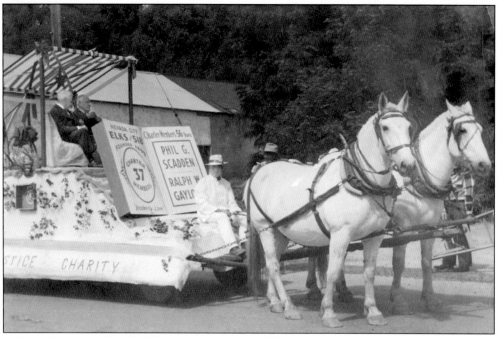

In Nevada County, Fourth of July celebrations are held in Nevada City in even-numbered years and in Grass Valley in odd-numbered years (the towns are four miles apart). In this photograph, Lawrence Personeni is driving the Nevada City Elks' Lodge No. 516 float entry in the parade in Grass Valley. Lawrence is the owner of the horses that are pulling the float. (Miller family.)

Andrew and Maria Personeni sold their ranch in 1948 or 1949 and moved into a house on property that Phil and Louis had purchased on Personeni Lane. Phil continued to operate his ranch with his wife, Johanna, and their children. This photograph shows a Personeni cattle drive and cows going up Studhorse grade in Sierra County. (Miller family.)

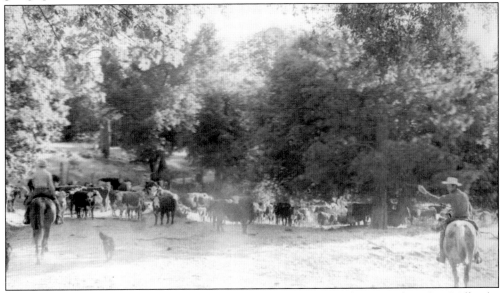

This photograph shows the 1975 Reader Ranch roundup. In the foreground are Jim Miller (at right) and Phil Personeni. Jim and Linda Personeni Miller (of the Personeni/Miller ranch) were married in 1970. Jim was one of twelve children born to Raymond and Opal Miller in Nevada City. (Miller family.)

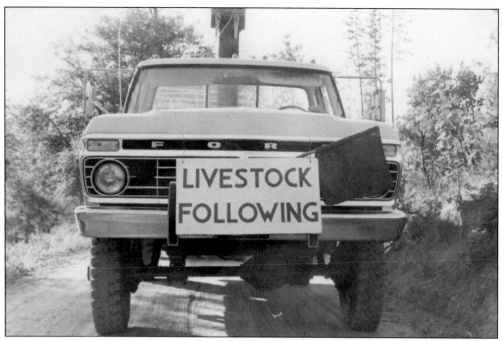

This truck's "Livestock Following" sign is intended to alert oncoming traffic that cattle are following on public roads. The animals always have the right of way during a cattle drive. (Miller family.)

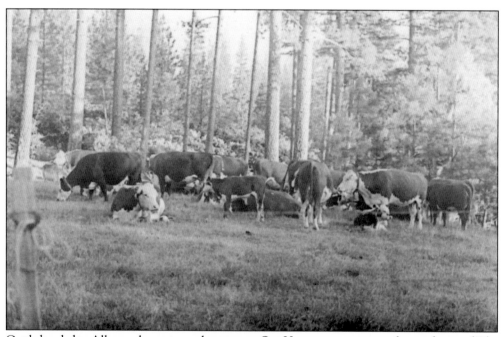

Cattle headed to Allegany have stopped to graze at Our House, an area two miles southwest of Pike in Sierra County. The Personenis ran both cattle and sheep on the same ranch. The cows grazed on different parts of the ranch than the sheep. This photograph is undated. (Miller family.)

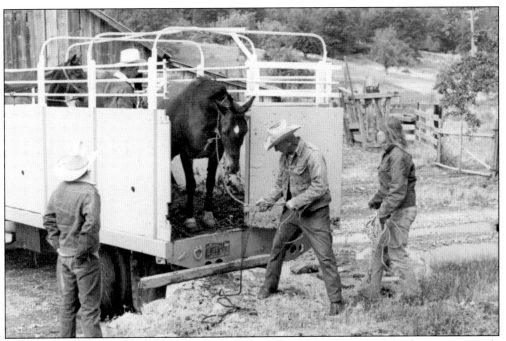

This undated photograph shows horses being unloaded at the Personeni ranch after a spring cattle drive. Kenny Smith is standing in the left foreground, Phil Personeni is leading horses out of the trailer, Linda Miller (Phil's daughter) is on the right, and Jim Miller is in the trailer guiding the horses. (Miller family.)

Jim Miller is shown squatting on a tree he had been cutting up near Brandy City in Sierra County in 1982. The diameter of the tree was originally eight feet and eleven inches. Miller worked in the timber industry for over 25 years. The rest of his life was spent ranching on Bitney Springs Road as a farmer, and he loved the land and all of his animals. (Miller family.)

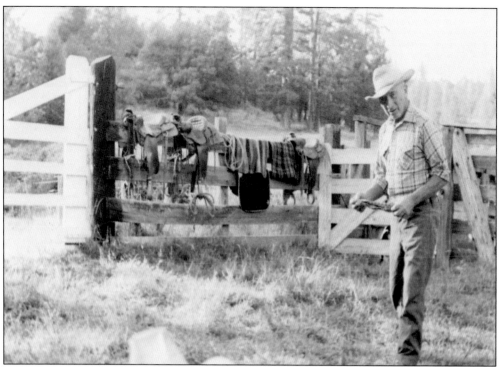

This photograph shows Phil Personeni on his ranch. Besides being a rancher and a member of the Farm Bureau since 1946, he was very active in the community. He was a member of the Purebred Beef Breeders, a group formed to promote the Junior Livestock sale at the 17th District Fair, and he served as the group's director from 1966 to 1977. He was named the Tahoe Cattlemen's Association Cattleman of the Year, and he served as president in 1980–1981. (Miller family.)

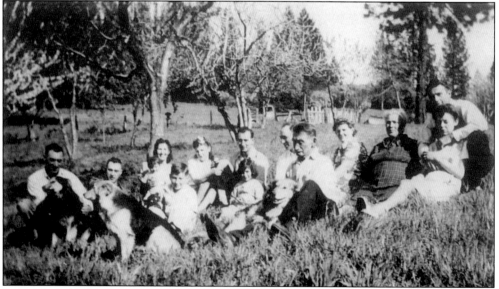

Pictured on the family ranch around 1940 are Personeni family members (in no particular order) Louis, John, Antoinette (with son Bob on her lap), Hazel, Mario, Phil, Johanna, Maria, Laurence, Betty, Phil Jr., Marie, and Andrew. (Miller family.)

Eight

FRENCH CORRAL AND NORTH SAN JUAN RIDGE
BROWNING AND READER

French Corral and North San Juan, located in Bridgeport Township, were once thriving towns in the high country of Nevada County located between the Middle and the South Yuba River and "the ridge" that divides the two streams. General knowledge says that a group of Frenchmen came over from Grass Valley and settled there. In 1849, a French settler built a corral in the area for his mules and discovered gold in a rich ravine. The miners living in the area adopted the name French Corral, and by the spring of 1852, a small town had been established. The Browning families who live in French Corral today are descendants of an early Frenchman, Philippe Moynier, who settled there. Moynier immigrated to the United States (arriving in New York) in 1857 as a young man of 17. When he heard about the golden wealth of California, he joined a wagon train and came across the plains. Upon arriving in California, he went to Sierra County and was mining in the area west of Forrest City by 1860.

North San Juan became the principal town on "the ridge," thanks to its central location near a series of settlements and mining camps in the area. Early German pioneer and miner Christian Henry Kientz built a hotel and named it San Juan. By 1857, the town had grown large enough to need a post office. When the application was sent in, another town in California had already taken the name San Juan, so "North" was added to "San Juan."

The Reader Ranch on Shady Creek—between North San Juan and Cherokee—was founded by early pioneer James Reader, who came west from southern Wisconsin in 1854 seeking adventure. He mined on Shady Creek, cut lumber, and purchased the early Johnson land there with a man named Jeff Bailey, his longtime friend. They constructed a sawmill on the rocks above the bridge and added many buildings, including the cabin where they lived and a boardinghouse for the men who worked in the sawmill behind where the Reader house still stands today.

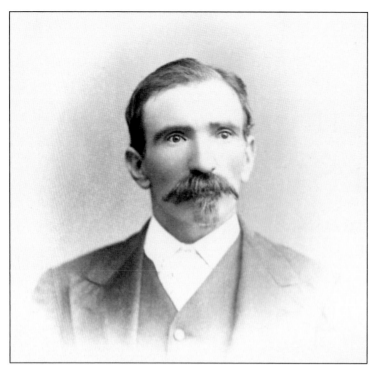

Philippe Moynier, born in France in 1840, joined other Frenchmen venturing to the United States and lived in Sierra County before settling in French Corral. He married Victoria Eugene Fournier in 1877 at the home of her parents, Felix and Emma Marie Fournier, at Charcoal Flat near Downieville. Victoria's parents were French, and Felix was a miner and a farmer. (Browning families.)

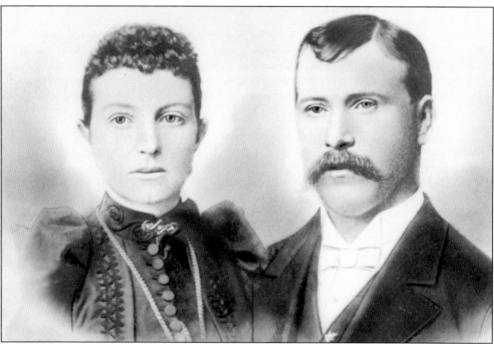

This is the 1884 wedding portrait of William Mann Browning and Theresa Anne (Annie) Lutz. Annie, the daughter of Bernard and Mary Lutz, was born in Nevada City in 1865. Her father owned a store that was destroyed in the Nevada City fire of 1863. William died in 1916, and Annie died in 1960 after living, in her later years, with her daughter-in-law Adele Browning. (Browning families.)

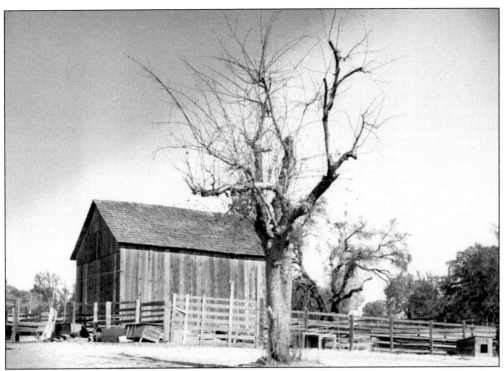

This barn is the oldest that has been in continuous use in Nevada County since 1866, when Philippe Moynier purchased property in French Corral. During its heyday, the town had a hotel, dentist, doctor, drugstore, butcher shop, telephone office, and other buildings. The decline of North San Juan and French Corral came after hydraulic mining was banned by the Sawyer Decision in 1884. (Browning families.)

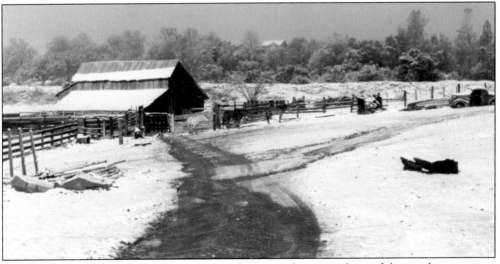

The Browning family's new, enlarged barn is shown on the original site of the ranch on a snowy day. Adele Moynier Browning, daughter of Philippe and Victoria Moynier, born and raised in French Corral quoted a friend who was mailing a letter to Adele in French Corral and was told there was no such place. Her friend told the postmaster in San Francisco that French Corral was a thriving town when San Francisco was nothing! (Browning families.)

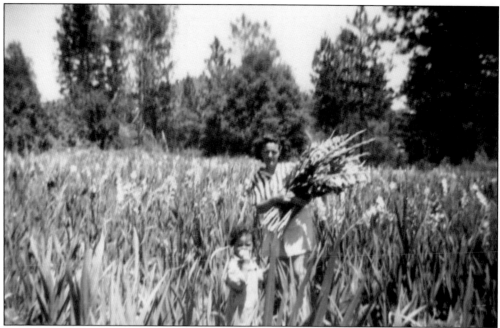

Adele Browning lived to be 101 years old and had the same teacher from the first to the tenth grade. Normally, the school only went to the eighth grade, but the teacher told her that if she wanted to come down another year, she would teach her, and she kept that promise. This 1920s photograph shows Adele and a girl (who is probably her daughter Irene) picking gladiolas that she raised and sold. (Browning families.)

William Browning, son of Adele and Aarnon (Aaron), is shown riding on the ranch where he lived all his life except when he served in the Army during World War II. William served as a foreman with the road department for 25 years and was an avid hunter who enjoyed the outdoors. (Browning families.)

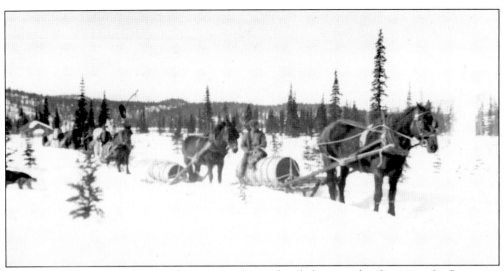

These horses are towing pipe in the snow in this undated photograph taken near the Browning ranch. In 1958, a special water district was formed consisting of 3,840 acres of land around the French Corral townsite. A great deal of the land could not be served with the water, and property owners asked to be excluded from the district. (Browning families.)

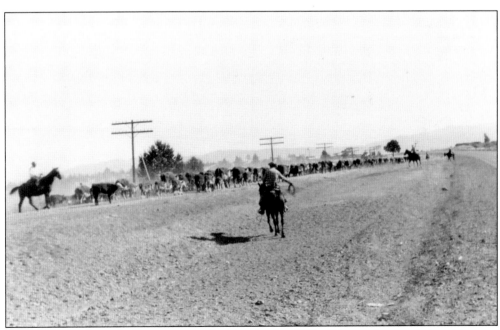

This photograph is of a Browning cattle drive in the 1960s. The cattle were being driven to higher country, where there would be plenty of grass and water to get them through the hot and dry summer. (Browning families.)

Cattle are grazing on the Browning Ranch in this undated photograph. The ranch had chickens, horses, cows, hogs, and large gardens to grow vegetables. The Brownings had to get through the winters on what they grew and produced, and they used the barter system to trade with neighbors. (Browning families.)

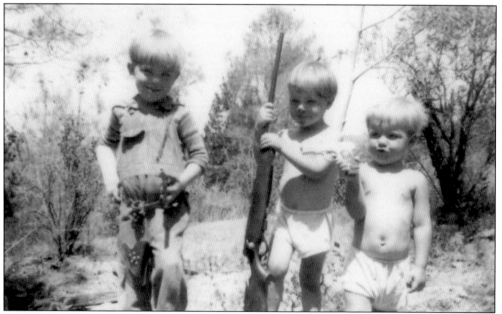

Just about every little boy who grows up on a ranch wants to be a cowboy when they grow up. The children of William "Bill" and Cecilia Browning—Billy (left), Melvin (center), and Pat—are posing in this c. 1940 photograph taken on the ranch. Important note: the rifle is not loaded. (Browning families.)

In this early 1940s image, Billy Browning, around age three, is learning to ride Trip the horse. Today, some ranchers think horses are more trouble and work than they are useful. Most modern ranchers own various four-wheel-drive vehicles that have taken the place of horses. (Browning families.)

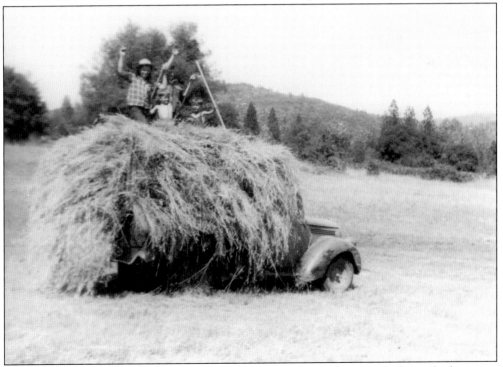

Haying was a necessary chore on every ranch. This undated photograph shows the haying is complete. The truck is loaded to capacity, and William Browning and his sons Billy, Melvin, and Pat appear to be very happy that the job is finished. (Browning families.)

William Browning and his son Pat are shown branding a cow on the ranch. Pat grew up on the ranch where his family has been living since 1866. Today, Pat and his wife, Nita, manage the ranch along with their grandson's help—that makes six generations of continuous Moynier/Browning family members living on the land. (Browning families.)

This mama cow does not seem to mind that this baby is not a calf as she feeds a piglet in this undated photograph from the Browning Ranch. The piglet may be an orphan, or perhaps its mother was sick and could not nurse—or maybe it just wanted a little extra milk. (Browning families.)

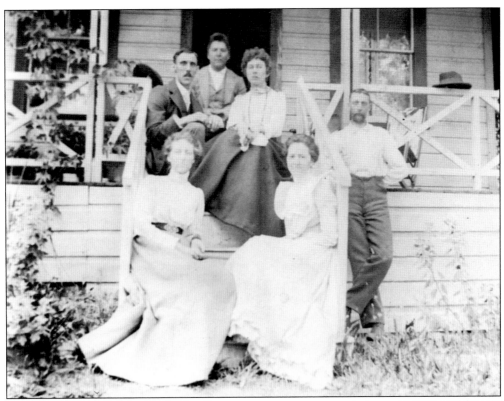

Sitting on the steps of the Reader family home are four of the children of James Harris Reader and his wife, Almina Judd Reader. In the front are Hattie (left), Nettie (center), and Frank (standing by the railing). Seated above Hattie and Nettie is Lottie Reader (along with two unidentified men). (Reader family.)

Clara Bell Reader, born in 1864, was the first child of pioneers James and Almina (Minnie) Judd Reader, who met in San Francisco and were married in the Palace Hotel. Clara went to Mrs. Hover's Private School in North San Juan. She married Charles Alpers, and they had eight children: Vesta, Doris, Carl, Randolph, Amanda, Minnie, Grace, and Myrtle. Charles was a miner, and the family lived in Grass Valley. (Reader family.)

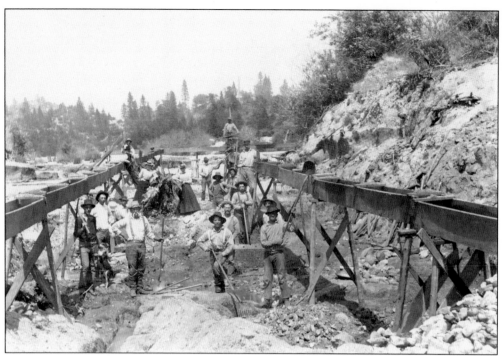

This c. 1900 photograph shows the Shady Creek Mine. Frank Reader is at left wearing a dark hat. Joseph Dudley is standing the foreground with a mustache, white shirt, and suspenders. The women in back include Lottie Reader and Nettie Reader Dudley. Others shown in the image include, in no particular order, Charles Wickman, Walter Trodd, Joe Dudley, Charles Hill, Will Dudley, Will Mather, Will Davidson, George Rodgers, Mel Treadwell, Walter Dudley, Brownie Dudley, and John Bristow. (Reader family.)

The boardinghouse in this undated photograph was built on the Reader ranch so that loggers could live nearby. When James Reader arrived in the area, loggers often wrote in letters home about the huge first-growth trees; people back east had never seen trees that large. (Reader family.)

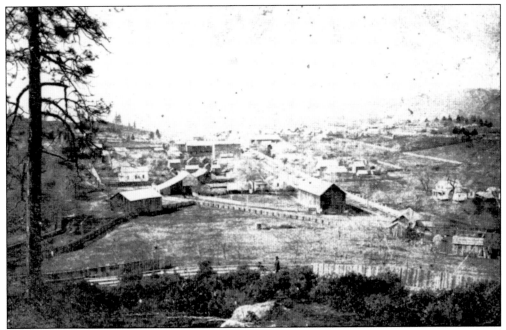

In 1853, there were only a few cabins and stores in the area. Henry Christian Kientz owned and occupied a ranch and boardinghouse below the east end of "the hill" and had the most favorable position for a townsite. In 1963, a bronze plaque was put up in memory of Kientz and all the pioneers and Argonauts of San Juan Ridge. (Reader family.)

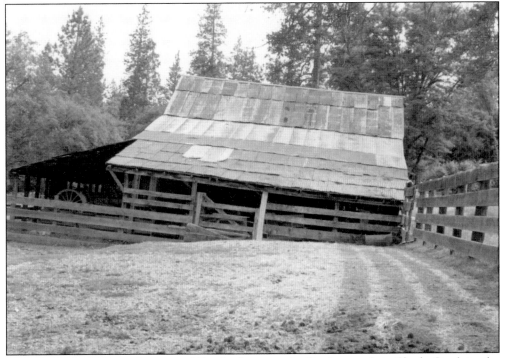

This photograph shows the original Reader barn on the Reader ranch in Shady Creek in the 1930s. It later burned down, and a new barn was built to replace it. (Reader family.)

Francis Reader, born in 1914, is the son of Frank and Sarah Nugent Reader and one of their nine children. This photograph was taken prior to 1994. His maternal grandmother, Sarah J. Nugent, was born in 1868 at Jones Bar, making him a fourth-generation native of Nevada County. His grandfather James M. Nugent drove a mule train from Missouri to California. (Reader family.)

These cattle are on the road to cow camp in this undated photograph. A number of the cattle are wearing bells that had a distinctive sound; cowbells are used to keep track of grazing animal herds. (Reader family.)

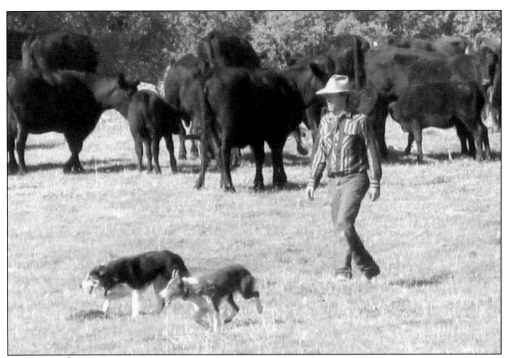

This undated photograph taken at cow camp shows Francis Reader and his two working cow dogs. Reader and his cattlemen (and dogs) had to keep track of over 150 cattle on this drive and after they made camp. The Reader family owns property in the mountains and leases property in the valley to which they can move the cattle. (Reader family.)

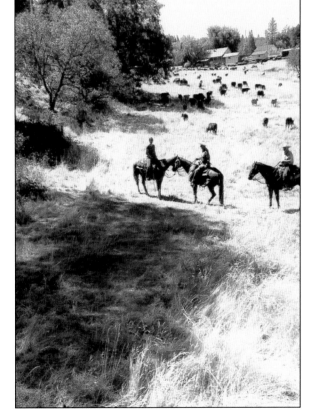

The Reader family still runs cattle in the fall and spring, and this is now Nevada County's only remaining cattle drive. They round up the cows from summer pasture near Allegheny and drive them along Highway 49 at the Middle Fork of the Yuba River and back to the Reader Ranch. (Reader family.)

This 1960s photograph shows Francis and Yolanda Reader on their way to Malakoff Days. They were the parents of Rich, John, Dave, and Robert Reader and Fred and James Langdon. Yolanda was a longstanding member of the Native Daughters of the Golden West. (Reader family.)

John Reader (pictured) and Fred Langdon developed springs on the ranch by digging and laying on rock where the water boils up, then diverting the water into tanks at each spring and laying pipes to different areas of the ranch for the cattle to drink. In 2006, the brothers were awarded the Conservationist of the Year Award from the county's Resource Conservation District. (Reader family.)

Pictured here at cow camp are, from left to right, Gary Foster, Fred Langdon, Tom Browning, and John Reader. Brothers John Reader and Fred Langdon manage and operate the nearly 1,000-acre ranch near North San Juan. (Reader family.)

The cow camp crew pictured in this 1960s photograph includes, in no particular order, Charlie Wickman, Walter Trodd, Joe Dudley, Charlie Hill, Frank Reader, Will Nether, Will Davidson, George Rodgers, Will Tradwell, Wallis Dudley, Stanley Housel, Bronnie Dudley, Father Dudley, and John Bristow. (Reader family.)

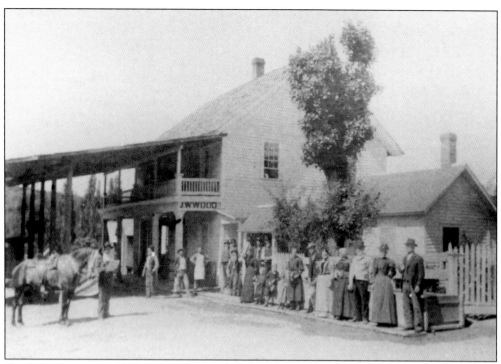

Frank Reader, born in 1871, is standing at far left in the roadway in the town of North San Juan in this undated photograph taken in front of the W.J. Wood Store and Hotel. Reader appears to be perhaps reading to and/or addressing the townspeople. (Reader family.)

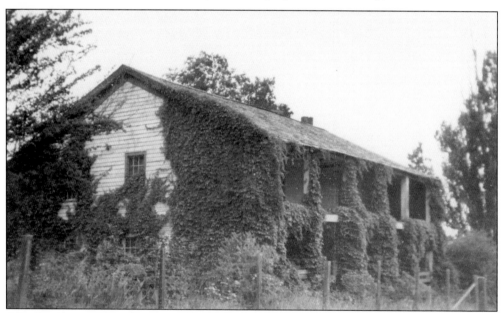

Allowing ivy to grow on houses and buildings was in vogue in the 1930s, as demonstrated in this picture of the old hotel at French Corral. Besides being famous for its rich gold mines, French Corral was famous for being the terminus of one of the first long-distance telephone lines in the United States; it was installed by the Edison Company in 1877 at a cost of $6,000. (Browning family.)

Nine

PENN VALLEY AND SPENCEVILLE

BROWN, NICHOLS, NIESEN, AND ROBINSON

Penn Valley and Spenceville are within the boundaries of Rough and Ready Township. In the mid-1850s, Rough and Ready was a booming gold-mining area and the third-largest town in Nevada County. Penn Valley is mostly rolling hills with 2,000 acres of good agricultural soil. Before the Gold Rush, the land was originally timbered with grand and giant oaks and did not contain the extensive mineral belt that runs through a great part of Nevada County. Early mining in this region was confined to beds of small streams, ravines, gulches, flats, and side hills. The pioneer families of Andrew Young Brown, who came from Iowa in 1863, and Thomas Jefferson Robinson, who left Ohio and settled in Penn Valley in 1874, became successful ranchers and farmers, and their descendants still ranch and live in the area today. The pioneer of today's Niesen Ranch was James Ennor, who came to California from Cornwall in 1852 and purchased land between the towns of Rough and Ready and Penn Valley.

The town of Spenceville, located southwest of Rough and Ready, came into being—along with early settlements—after James Downey discovered a large deposit of copper three feet in thickness while prospecting in 1863. This brought thousands to the area, and they sunk hundreds of shafts in hopes of a rich strike. The whole region—10 miles wide and 20 miles in length—was filled with hopeful miners. One of the early settlers in that part of the region (who was in the area before the short-lived copper boom) was Dawson Nichols, who left Indiana and arrived in Nevada County in 1852 and established his ranch by 1854.

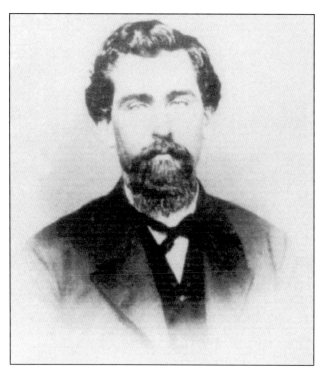

Andrew Young Brown was born in Jefferson County, Missouri, on the Little Sock River in 1839, although his family originally came from Virginia. He left Missouri in 1859 to seek his fortune in California, leaving on a horse and driving cattle across the country. He married Merinda Rouse on August 12, 1867, in Nevada County. (Graham family.)

This is believed to be the wedding photograph of Wade Rupert Brown and Jennie Watt, who were married on July 15, 1903, at Indian Springs at the home of the bride's parents. Wade's mother, Merinda Rouse, came to California in a covered wagon at age four with her parents, William Lemaster Rouse and Permelia "Amelia" Blazer Rouse, and her siblings. (Graham family.)

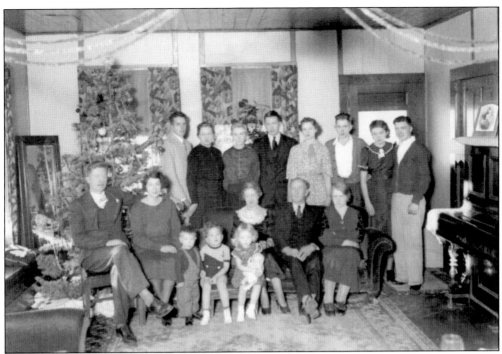

Wade and Jennie Brown were photographed on January 1, 1937, with their children and grandchildren. The couple had seven children: Ivan, Gladys, Arthur, Verda, Melvyn, Bertha, and Mildred. Melvyn "Mel" Brown is pictured standing third from right. (Graham family.)

The old Brown barn (pictured here) is no longer standing. Mel Brown was born in 1918 on the family ranch, and he built his first little building when he was eight years old. Through the eighth grade, he attended the one-room Indian Springs School, which was also where his parents were educated. (Graham family.)

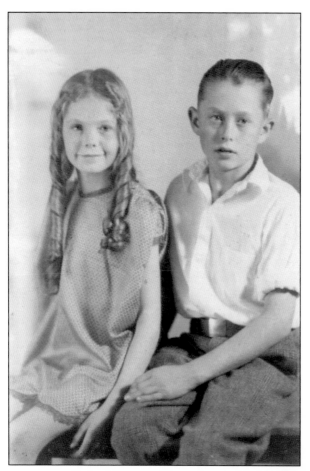

This photograph shows Mel Brown and his youngest sister, Mildred (nicknamed "Baby" because she was the youngest in the family). At age 13, Mel got his first automobile, a used 1926 Chevrolet. He would drive his sister and other neighborhood children to school one mile down the road. (Graham family.)

Mel Brown used his dozer to relocate this large rock. Before Mel was of legal age to drive, he needed to drive his mother into town to deliver eggs and milk. His mother, Jennie, called the local California Highway Patrol Office to ask Captain Blake if it would be all right for Mel to drive her around, and Blake asked his mother if Mel knew how to drive. (Graham family.)

Mel Brown had a lot of experience driving various kinds of farm equipment in his lifetime. This photograph shows him with two dozers putting in a new pond for the cattle. By the mid-1950s, he was in charge of the Brown dairy business, which had grown to 130 cows. (Graham family.)

Bertha "Bert" Kelly came to California with her family at age three. She met Mel Brown on New Year's Eve in 1936 at the dance hall on LaBarr Meadows Road. Mel cut in while Bert was dancing with his friend. That night, Mel told his friend that he was going to marry that girl. This photograph shows the barn and outbuildings on the Brown Ranch. (Graham family.)

In this photograph, Mel Brown has a steer in the cattle stop. Throughout Mel's childhood, his family lived entirely off the land, raising dairy, beef cattle, sheep, pigs, chickens, and turkeys. They grew Milo maize, soy, and other grasses. Mel's mother, Jennie, took care of the large vegetable garden that fed the family. (Graham family.)

Robb Graham is the grandson of Mel Brown. Robb now manages and lives on the Brown ranch (officially named the Flying MB Ranch) with his family. In this photograph taken in the spring of 1982, Mel (right) and Robb are bucking hay at the ranch in Tisbero Field. (Graham family.)

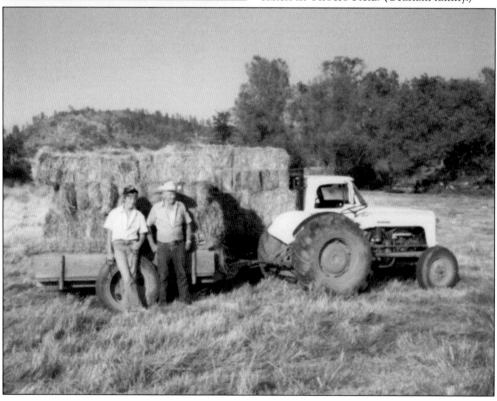

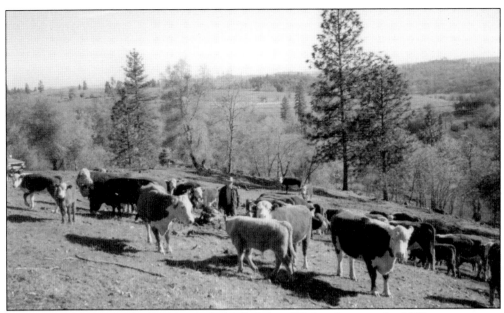

In addition to owning the Brown ranch, Mel's father, Wade, also rented a 1,100-acre property adjoining his farm to graze his cattle and grow Milo maize from 1903 to 1942. After his father's death, Mel also grazed some of his cattle on several other ranches. In this undated photograph, Mel is walking his land and inspecting his herd. (Graham family.)

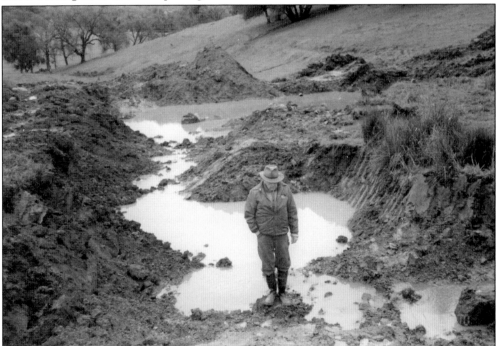

Mel Brown is shown surveying the area he has been clearing out to build a new pond for the cows. Brown stands on the land on which he was born and worked for his entire life. After his sophomore year of high school, he was needed on the ranch. In 1938, Mel and his father, Wade, decided to go exclusively into Grade A dairy farming. (Graham family.)

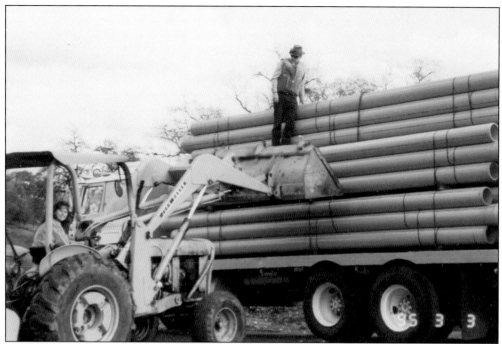

Besides all the responsibilities of running the ranch, Mel Brown became a trustee of the Indian Springs School Board and helped lead the movement to combine Rough and Ready's school district with Penn Valley's, making possible the building the new Ready Springs School. Brown is shown in this photograph supervising the unloading of pipes for the ranch. (Graham family.)

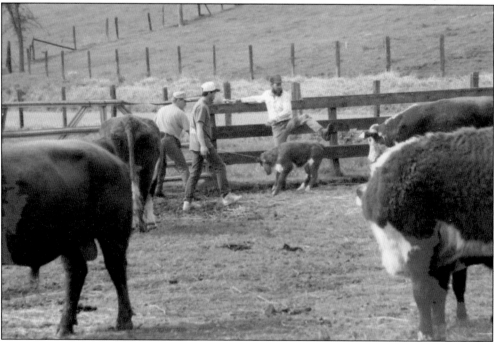

Robb Graham, on the left, and his cousins Randy Koster (center) and Ronald Koster (right) are pictured working on the Brown ranch. They are seen here ear-tagging a calf. (Graham family.)

Dawson Nichols left Terre Haute, Indiana, in a covered wagon in 1851 and arrived in California in 1852. He found the property he wanted near what would become the town of Spenceville on Dry Creek. He purchased cattle, a 1,000-acre ranch and farm that contained two creeks, and a three-acre access road. The original house on the property was watered by a spring. (Collins family.)

Elizabeth Chandler married Dawson Nichols in 1850 in Hancock County, Illinois. Elizabeth and Dawson had 11 children: Nevada Adeline, Simon Peter, Lona Minah, Peter, Alice C., Frank, Jessie, Elizabeth, Margaret Belle, Ella May, and Imogene. In 1870, they moved to an area that had a plentiful water supply, and Dawson built his wife a long-promised Victorian house. (Collins family.)

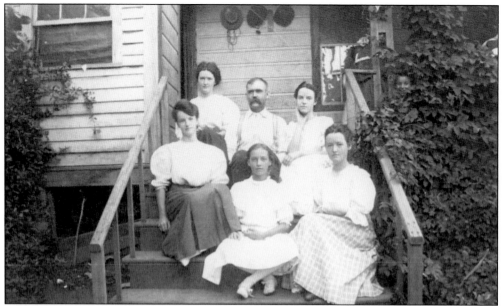

Frank, a son of Dawson and Elizabeth Nichols, is shown here with his five older daughters, Freda, Bertha, Ruth, Hazel, and Vesta Nichols. The girls were borne by his first wife, Viola Shetterly, who died from complications of childbirth in 1898. Frank remarried in 1920—to Grace Shetterly—and they had three daughters as well as a son named Frank. The name of the child peeking through the bushes at right is not known. (Collins family.)

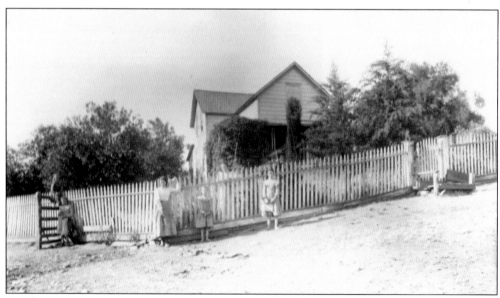

Standing outside the fence of the Frank Nichols home are his five daughters (from left to right): Vesta, Ruth, Freda, Hazel and Bertha. This photograph dates to the early 1900s. (Collins family.)

After the death of his parents, Dawson and Elizabeth Nichols, Frank purchased the interests of his brothers and sisters and operated the ranch until he died in 1937. This undated photograph taken on the west side of the Nichols home shows Frank's daughter Ruth standing on the right; the other person is not identified. (Collins family.)

The Markwell School (pictured here around 1904) opened on February 7, 1902. The teacher was Clare Morshead, and the clerk was Samuel H. Shetterly. The older group of children standing in the back includes the daughters of Frank Nichols. At this time, all white children between the ages of 5 and 21 years were entitled to school privileges. (Collins family.)

This photograph was taken prior to 1939, when the Nichols family was forced off their land in order to expand Camp Beal. Pictured here are Grace Shetterly Nichols (standing at farthest left) with her children Frank (standing in the front) and, from left to right next to Grace, Zylpha, Elizabeth, and Beverly. (Collins family.)

The old Nichols barn (pictured) was located south of the house on the Nichols property that was seized. Prior to World War II, the War Department took 40,000 acres of land by eminent domain from landowners in Spenceville, Penn Valley, Smartsville, and Camp Far West. The previous owners received letters that their land was going up for auction in 1959. (Collins family.)

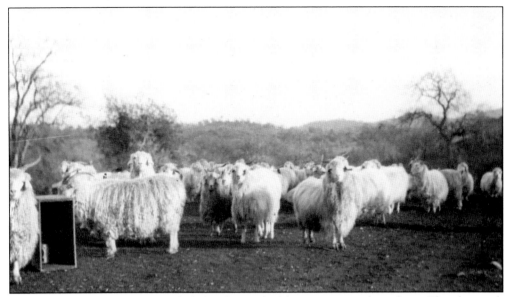

It is not known what year the Nichols family switched from raising cattle to sheep. Their livestock was marketed, usually in Marysville, after the fall roundups. At the time, provisioning was done in Marysville, which was the largest town near the ranch. This undated photograph shows the Nichols family's Angora goats. (Collins family.)

Jack—the "chauffeur" of the Nichols family—appears to be driving the automobile in this fun picture. When Frank Nichols retired in the early 1920s, he stopped taking the cattle to high country in the summers. At the time, the Nichols Ranch consisted of over 1,000 acres. (Collins family.)

It was reported in the *Nevada City Herald* on January 20, 1887, that Dawson Nichols sold a steer weighing 2,038 pounds (live weight) to Frank Aumor, who sold it to a butcher in North Bloomfield. Aumor also bought three other steers at the same time nearly as large from Nichols. (Collins family.)

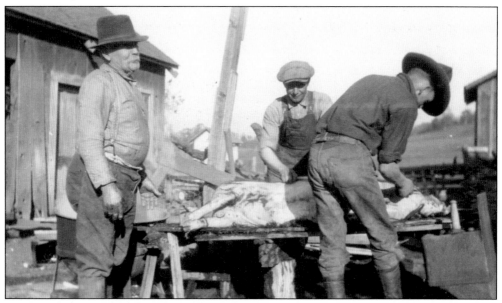

Frank Nichols is on the left in this undated photograph taken at the Peckman Farm as he stands with his neighbors on butchering day. The animal being butchered does not compare with Nichols's prize cattle. (Collins family.)

This photograph shows Mr. Deeds (on the right) during the building of the cement bridge at Spenceville two miles from the Nichols home. After World War II was over and the government decided they no longer needed all the surplus land, descendants of the Nichols family were successful in buying back about half of their original acreage that included where the original structures once stood. (Collins family.)

Jesse Ennor was the youngest child of pioneers James Ennor and Ellen Elizabeth Foulkes. His parents met on a ship sailing to the United States; Ellen was 14 years old. Both families settled in Wisconsin, but James caught gold fever and went to California on a wagon train. He found gold and bought a ranch, then went back to Wisconsin to bring his bride, Ellen, to Nevada County. (Niesen family.)

The Ennor family were some of the earliest permanent residents of the area. In this c. 1888 photograph are, from left to right, (first row) George Waggoner, Sadie Martel, Birdie Martel, Dolph Rex?, Sadie Hammill, Bill Waggoner, and Tom Casey; (second row) Lester Martel, Edith Hammill, Frank Ennor, Nell Ennor, unidentified, and Adele Ennor; (third row) Ross Cooley, Abbie Hammil, Alex Martel, Jesse Ennor, John Hammill, Henry Carr, and Bill Torpie. (Niesen family.)

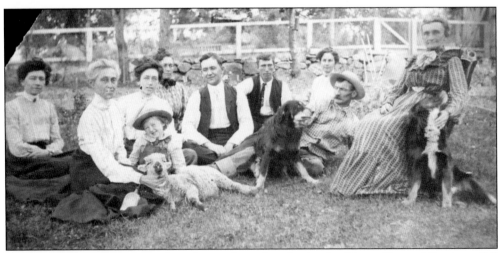

This photograph is believed to have been taken after the death of James Ennor following a fall from a horse in 1895. From left to right are Adele Ennor, Amelia Ennor, Sadie Ennor Hammill (with little Malcolm Hammill in front), Nellie Ennor, John Hammill, Jesse Ennor, Cora Nile Ennor, Frank Ennor, and Ellen Foulkes Ennor. Ellen's seven living children are in the photograph; her infant son William died in 1876. (Niesen family.)

Cora Belle Nile was the daughter of James Nile and Isabella Medora Marsh. She married Jesse Ennor on November 13, 1904, in Nevada County. After their marriage, the couple first lived at the Nile Ranch, which later became the Peacock Ranch. This photograph was taken on their daughter Dorothy's first birthday on August 26, 1909. (Niesen family.)

Jesse Ennor (at right) is working to redirect his creek. The two Fresno Scrapers in this photograph were invented in 1883 by James Porteous and named for Fresno, California, agriculture workers. The Fresno Scraper lifted the soil into a C-shaped bowel where it could be dragged along with less friction than the older method. They played a vital role in the construction of the Panama Canal and in US Army fighting in World War I. (Niesen family.)

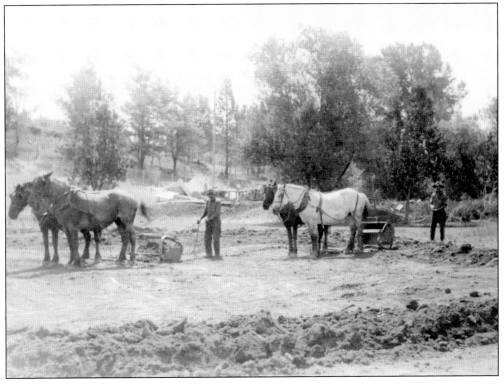

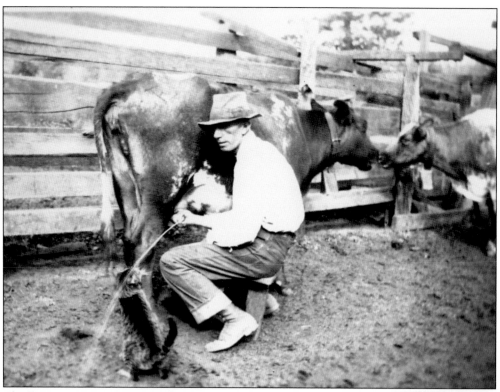

The Ennor property was originally homesteaded in 1849 by Madame Penn, who was supposedly the namesake of Penn Valley. Jesse Ennor's father, James Ennor, purchased the 600-acre property in 1852. In this photograph, Jesse is milking a cow (and sharing the milk with a hungry cat). The ranchers raised cattle, sheep, hogs, and turkeys and grew vegetables and fruit for market. (Niesen family.)

The Ennor barn was built during a community barn-raising in 1884. When James Ennor was looking for land to settle on, he found the Penn property that contained an intersection of two creeks (later named Squirrel and Grub Creeks). Decades later, the Nevada Irrigation District was formed to provide ranches and farms with a reliable water source. (Niesen family.)

This c. 1913 image shows Dorothy Belle Ennor, daughter of Jesse and Cora. Dorothy's grandmother, Ellen Ennor, owned and ran—along with her five daughters—a boardinghouse on Main Street in Grass Valley, the Ennor House, during the Depression. It later became the Morgan House. The Ennors also had a freight business, Woodruff and Ennor, that hauled wood to Grass Valley and vegetables to Virginia City, Nevada. (Niesen family.)

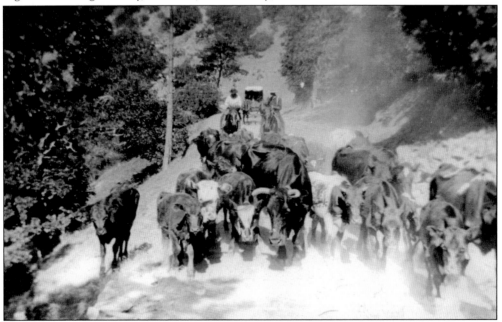

The spring cattle drive was a yearly highlight for the Ennor family. When James Ennor's cattle operation expanded in the late 19th century, it became necessary for them to drive the cattle to Jackson Meadows in the summer, preserving the grass on the ranch for the winter months. This 1914 photograph shows Jesse Ennor and Glen Martel on the second day of the drive on Bridgeport Grade. (Niesen family.)

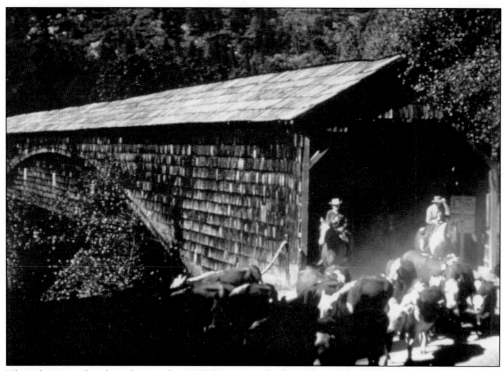

This photograph taken during the 1955 Ennor cattle drive shows the Bridgeport Covered Bridge when it was still in use. Jesse and Duane Ennor were trying to keep the cattle to a walk because the bridge wobbled as the cattle crossed. There was a three-mile climb from the crossing of the South Yuba River at the bridge to the old mining camp at French Corral. (Niesen family.)

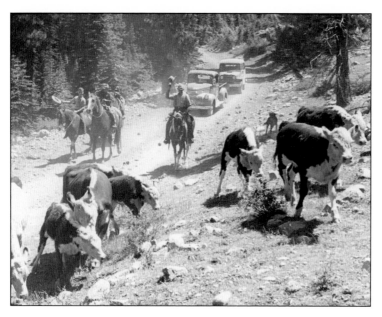

This image taken on the last day of the Ennor cattle drive in July 1955 shows their 1941 Chevy pickup truck following riders and cattle. Riding in the center is Jesse Ennor (on pony); to the left are grandsons Melvin Winslow and Gary Winslow. Jesse's daughter Lois Winslow is following in the pick-up truck, and behind is grandson Floyd Winslow in the second car. (Niesen family.)

The horses and cattle on the Ennor cattle drive are taking a rest at Bowman Lake in this photograph from the summer of 1958. Three of Jesse Ennor's grandsons are visible in the picture: Gary Winslow (right), Melvin Winslow riding "Caranay" (center), and Duane Niesen riding "Champ" (left). (Niesen family.)

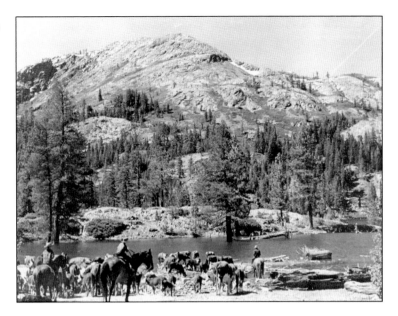

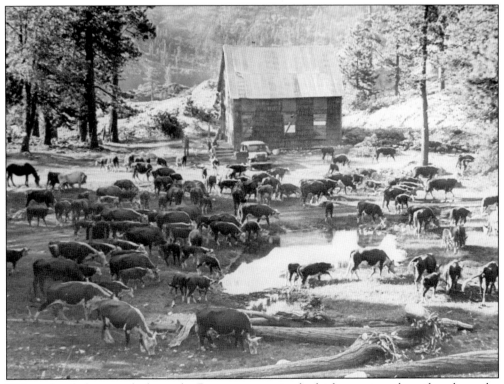

This undated photograph shows the Ennor property in the high country, where they drove the cattle each year. Before 1915, the Ennor family drove the cattle to Snow Tent near Graniteville; after that, they drove them to the pastures of Jackson Meadows, where they homesteaded 160 acres of forested land next to Crown Zellerbach Paper Company land until the Jackson Meadows Dam was built in 1965 and flooded the meadow. (Niesen family.)

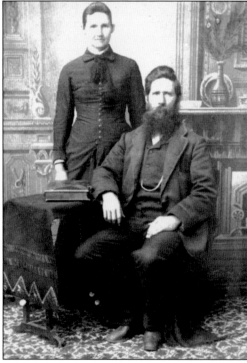

Duane Niesen, grandson of Jesse Ennor, grew up on the Ennor Ranch, and his grandchildren are part of the sixth generation of the family to live on the ranch. Duane said that mining was great, but agriculture is what kept people alive. In this 1946 photograph, Duane is plowing the ground at the Ennor property. (Niesen family.)

Thomas Jefferson Robinson was born in Virginia and moved to Ohio when he was young. He farmed and learned the blacksmith trade there, and when he turned 18, he enlisted in the 86th Ohio Regiment and fought in the Civil War. He arrived in Nevada County in March 1864 and established the Robinson Ranch in 1874. In 1871, he married Charity Ann. (Robinson family.)

This photograph shows Guy Vana Robinson, son of Charity and Thomas Jefferson Robinson, with his first wife, Ella Madora Nile, and their two children, Guy Nile and Avis Robinson. Ella was the daughter of pioneers James Henry Nile and Isabella March Nile, who settled the Nile Ranch in 1863. (Robinson family.)

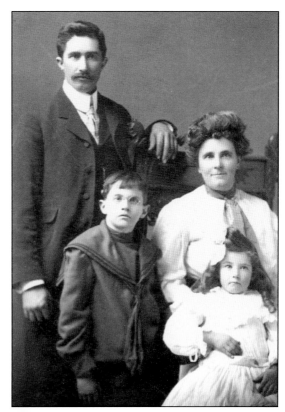

Olive Grace Alderman (pictured in 1919) was born in 1898 and was the daughter of Foster Alderman and Lillian Mitchell. She married Guy Nile Robinson in the late 1920s. She was active in the Farm Bureau, Banner Grange, and in the Placer-Nevada Cowbells. She had four sons: Donald and Robert Gates (with her first husband, Victor Gates) and Lowell and Neil Robinson (with Guy Nile Robinson). (Robinson family.)

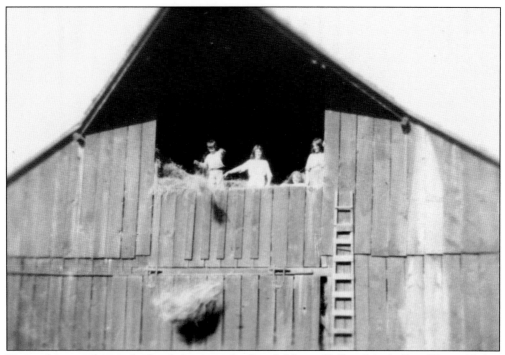

Pictured moving hay in the family barn are the five children of Lillian Mitchell and Foster Ferber Alderman (partly hidden by the doors and in no particular order): Olive Grace, Lola, Muriel, Ralph, and Alvan. Their father, Foster Ferber Alderman, was born in 1870 in Grass Valley to his parents, Richard and Catherine Ann Sanford, both members of early pioneer farming and ranching families in Nevada County. (Robinson family.)

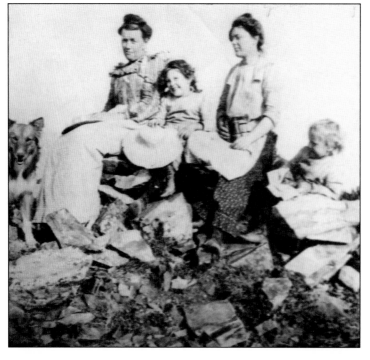

The Mitchell-Alderman family women are posing on the rocks at Grouse Ridge four miles north of Yuba Gap. In this c. 1900 photograph are, from left to right, Emily Mitchell, her granddaughter Olive Grace Alderman, daughter Lillian Mitchell Alderman, and youngest granddaughter Lola Alderman. (Robinson family.)

In rural areas of Nevada County, ranch and farm families donated a portion of their land for schools to be built for local children. The Robinson family donated land at Indian Springs, where their ranch was located, for the construction of a new school that was established on March 4, 1868. This photograph was taken when the school was new. The building is still standing today but is in poor condition. (Robinson family.)

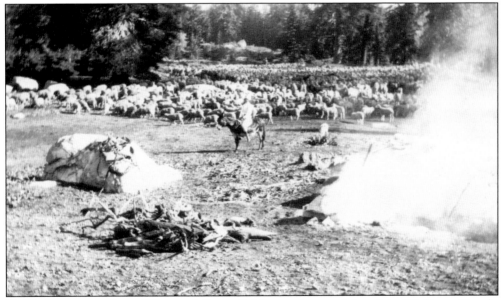

Neil Robinson, grandson of Thomas Jefferson Robinson, pioneer of the original Robinson Ranch, knew that he could make more money with sheep than cattle. In 1920, sheepmen and farmers raising other small stock met at the Union Hall on McCourtney Road to form an organization for protection against predator animals. (Robinson family.)

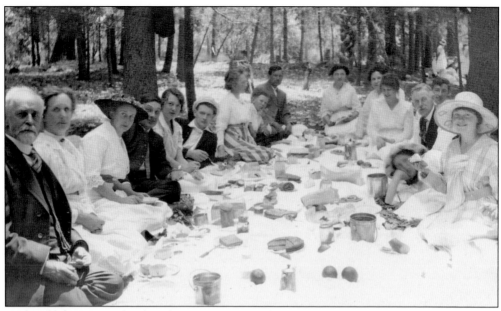

In the old days, it was hard work to maintain ranches and farms, but outings were popular. At the Alderman-Robinson family picnic pictured here, Lola Alderman is sitting at far right and her sister Grace Olive Robinson is the woman with the dark hat (third from left). Everyone else in this undated photograph is unidentified. (Robinson family.)

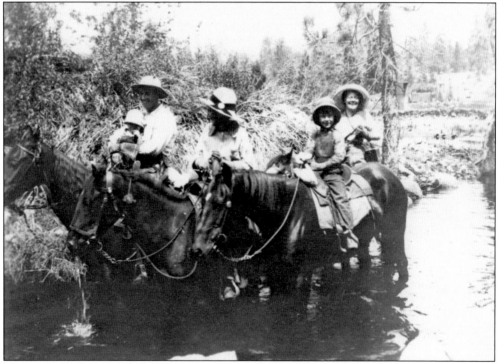

This undated photograph shows another outing of the Alderman-Robinson family as they went on a small family picnic to Sawmill Dam, located two and half miles west of English Mountain. There was a lake behind the dam. (Robinson family.)

The Robinson cattle are shown crossing the South Yuba River on the Bridgeport Covered Bridge that was built in 1862 by David I. Wood to haul heavy freight and supplies to the mines and to Virginia City, Nevada. Wood and his partners in the Virginia Turnpike Company had a toll road at the bridge; at the time, it was one of only twelve bridges in the entire county. (Robinson family.)

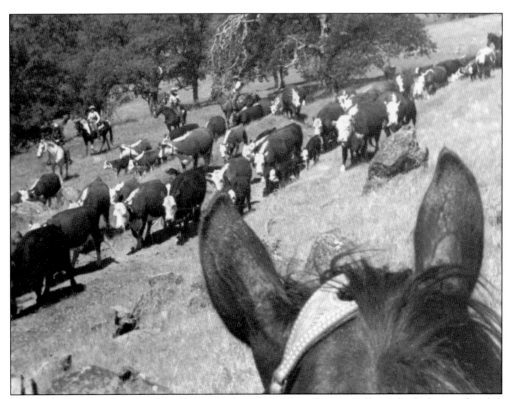

This scene shows part of a cattle drive to high county above Downieville to the Robinson family's Butler Ranch and Gold Lake. In September 1973, the Robinson family cattle drive, along with Grace Olive Robinson, was featured in *National Geographic* magazine. (Robinson family.)

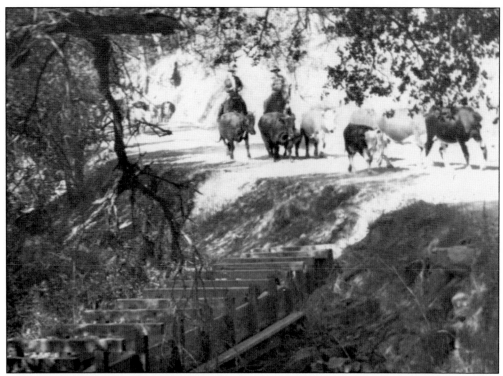

Guy Vana Robinson is on the right in this photograph of one of the many cattle drives he participated in during his lifetime as a rancher. He was said to be a progressive farmer who maintained a close knowledge of agriculture and stock-raising methods. (Robinson family.)

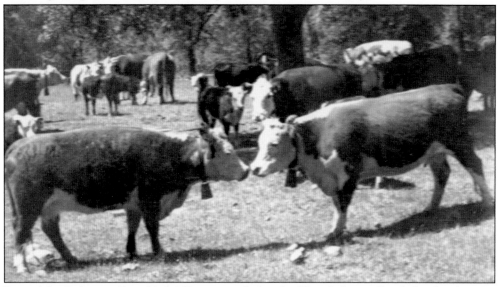

Part of the Robinson Ranch's 3,000 acres includes the Blue Oak woodland that borders the Spenceville Wildlife area. The Robinson family has ranched and lived on the same land since 1874, and members of the family noted that they could not afford to eat their own beef during the Depression. Early on, the land contained the old Hatch House that was a stage and wagon-train stop. It was torn down when the new house was built in 1906. (Robinson family.)

Ten

SOUTH COUNTY
BUTLER, SANFORD, AND SWEET

The area commonly referred to as "south county" is located southwest of the city of Grass Valley and within Grass Valley Township. While early settlers found that the land was not good for gold mining, it was very rich for farming and ranching. The Butler Ranch, located off what is now Lime Kiln Road, was said to be the first ranch in the area. Early pioneer Jonathan Butler was a farmer from Ohio and arrived in California in 1850 and settled on Squirrel Creek. Although much of the Butler family land was sold in 1961 by one of Butler's great-grandsons, Jim Tryon started buying back the Butler family land a parcel at a time.

The Sanford family is related to the Butler family by marriage, as is common with many of the early pioneer ranch and farm families. Ranching families had much in common. The Sanfords are also related to the Loney family, again by marriage. Benjamin Sanford was the last of four sons of James and Sarah Sanford to leave Nova Scotia for California during the Gold Rush. The four Sanford sons—James Monroe, Nathan, Levi, and Benjamin—did very little mining. They were involved in commerce, ranching, and farming. In 1872, Benjamin, the youngest son, went back to Nova Scotia to persuade his elderly parents to move to California. It is assumed that they traveled to California by train, since the Transcontinental Railroad had been completed by this time. James Sanford bought an acre of land from Thomas Loney for $1 and hoped to build a church near his home. Instead, the church was built in Grass Valley. A few years later, both James and Sarah died and were buried under a cluster of oak trees on the property. Today, they are at rest in the Loney-Sanford Ranch Cemetery.

When Pioneer William Sweet arrived in Grass Valley in 1864 from Cornwall, he was already an experienced miner and mechanic, having worked on mining machinery and equipment in England. The Sweet family is also related to the Butler and Sanford families by marriage. Sweet settled in the Wolf district and purchased the Underwood land. In 1871, he quit mining and began ranching full-time, with his descendants following in his footsteps.

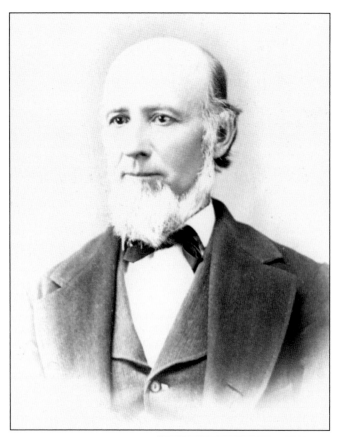

Jonathan Butler, a farmer from Carrollton, Ohio, was the pioneer of the Butler family who came to California in 1850. He settled on Squirrel Creek, and in 1869, he purchased the Chollar Ranch. His sister Amanda Butler Young, a widow, came to California to live with her brother and married Myles Poore O'Conner, who was a partner with John and Edward Coleman of the Idaho Mine. (Tryon family.)

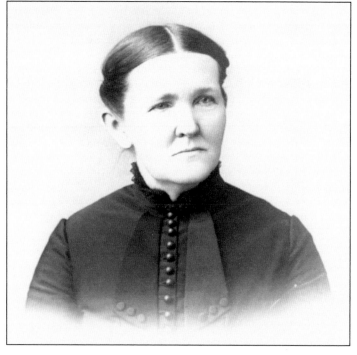

Rebecca Fawcett married Jonathan Butler in Carroll County, Ohio, in 1854. Jonathan went back to marry her and sailed back to California by the Isthmus of Panama to San Francisco and headed directly to Grass Valley. After Jonathan's death, Rebecca lived with her daughter Elizabeth and son-in-law John Werry and their family in Nevada City. Butler and Fawcett Streets in Grass Valley are named for this family. (Tryon family.)

This is a formal family portrait featuring Clara Lucinda Bergman and Benjamin Franklin "Frank" Butler, who were married in 1897. Frank had acquired the Butler Ranch in 1891. Pictured here are, from left to right, (first row) Clara, John Werry "Jack" Butler, and Benjamin; (second row) Eleanor "Ella" Butler, Charles Franklin Butler, and Daisy Amanda Butler. (Sanford family.)

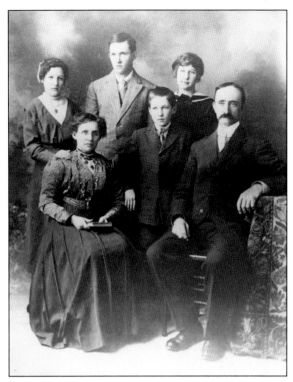

Frank Butler, known as the "Boss," added to the holdings of the Butler Ranch by acquiring an additional 640-acre homestead and land from the Central Pacific Railroad. Butler lived on the ranch for 63 years before retiring, then he and Clara moved into Grass Valley at 575 Butler Street. This photograph of Frank and Clara Butler was taken prior to 1959, the year Frank died. (Tryon family.)

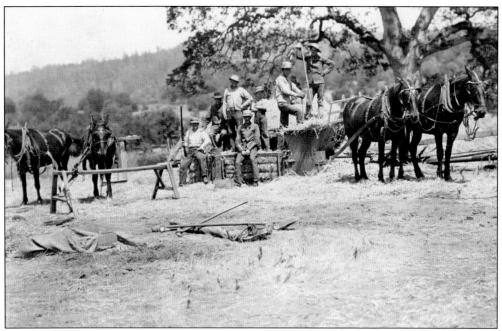

This undated photograph shows men working in the hayfield at the Butler Ranch. The pair of horses was changed every other turn to avoid fatigue. Charlie Butler; his sons Jim, Doan, and Frank Butler; and his nephews Tom Griffin, Vern Holmes, and Mick Bell are known to be in the photograph. (Tryon family.)

The four younger children of Charles F. Butler and Elizabeth "Bessie" Butler—Ruth, Albert, Nora, and Mike—are pictured here in 1930. Not shown are Charles James, Donald Lloyd, and Thomas Franklin Butler. (Tryon family.)

This aerial view shows part of the Butler Ranch. In 1870, the family put in the first pipe to run a water ditch. In 1948, 15,000 feet of pipe was installed for irrigation in to get water to different areas of the ranch. The ranch had two houses and four barns, and today, it has its own two-acre pond; cattle roam freely at the Butler Ranch. (Tryon family.)

In the 1920s, Charley Butler shot this bear at the Butler Ranch. Bears are predators and present a danger to sheep, cattle, and family members, especially children playing or working outdoors. (Tryon family.)

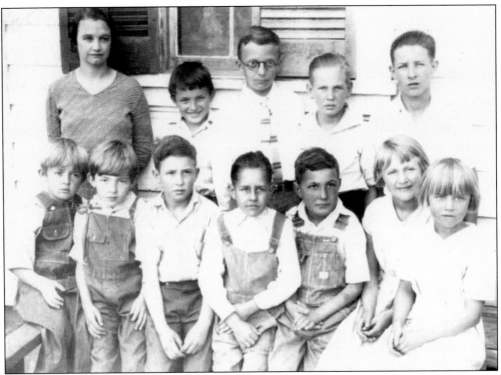

Frank Butler purchased land to build a school so that all of his grandchildren could go to the same school. Pictured here are, from left to right, (first row) Franklin Woody, Mike Butler, Archie Lillian, Myer Cole, and three unidentified children; (second row) unidentified teacher, Jim Butler, Elvin Cole, Allen Butler, and Tom Griffin. At the time of Frank Butler's death in 1959, he had 28 grandchildren, 55 great-grandchildren, and 2 great-great-grandchildren. (Tryon family.)

Jim (left), John (center), and Jannice Tryon are pictured on December 25, 1950, with Jim and Jannice holding bottles of milk that came from the Butler family dairy. During their childhood, the ranch had goats, pigs, sheep, and dairy cows. Their grandparents were Charley and Elizabeth "Bessie" Butler. (Tryon family.)

Euphemia Wallace married Benjamin Sanford in Boston, Massachusetts, in 1854. Euphemia went back to Nova Scotia, and Benjamin left for California. They sent letters back and forth, and in 1856, Euphemia and her one-year-old daughter, Eve, sailed to California. Euphemia was ill during the trip, and Thomas Loney helped her take care of baby Eve. Loney later married Benjamin's sister Lois Amelia Sanford. (Sanford family.)

Benjamin Sanford was the youngest of 11 children. In 1872, he went back to Nova Scotia to persuade his aged parents to move to California, and they did. Benjamin wanted to live to be 100, but he went out to get the mail on a hot day without wearing a hat and was later found dead. He almost met his goal, living to the age of 99 years and three months. (Sanford family.)

Eva Maria Sanford was the baby that sailed with her mother, Euphemia, to California in 1856. After sailing by way of the Isthmus of Panama, they crossed the land by mule and then had to wait for a ship sailing to California. All of her brothers and sisters were born in California. This is the wedding photograph of Robert Black and Eva, who were married in 1875 in Nevada City. (Sanford family.)

Wallace James Sanford and his family are pictured here at the 1915 World's Fair in San Francisco. They are, from left to right, (first row, seated) Wallace and Beatrice; (second row, standing) Sadie, Walter, Eva, and Earle. Wallace, the son of Benjamin and Euphemia Sanford, was called "Wall" or "W.J." Wallace and Eva are the parents of Jesse Monroe Sanford. (Sanford family.)

This formal photograph of Jesse Monroe Sanford was taken in the mid-1890s. He was born at the family ranch, now called the Paul Sanford Ranch, and was the oldest of the seven children of Wallace and Eva Jones Sanford. Eve's father, David, came to California in the early 1850s and was one of the first men to haul freight by ox team from Sacramento to Virginia City, Nevada. (Sanford family.)

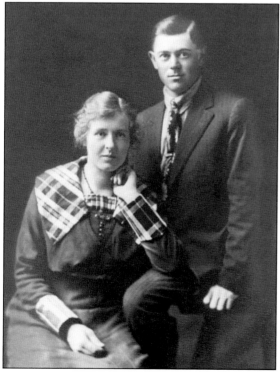

Jesse Monroe Sanford and Nettie Mae Calvin, daughter of Amos Lincoln and Nettie Howe Calvin, were married in 1915 in Dutch Flat, Placer County. They were the parents of seven children, all born in the Wolf district: Calvin, Glenn Willard, Eva Mae, Anabel, Evelyn, Jesse Ray, and Thelma Louise. Baby Calvin only lived for seven days. This photograph may have been taken on their wedding day or shortly after it. (Sanford family.)

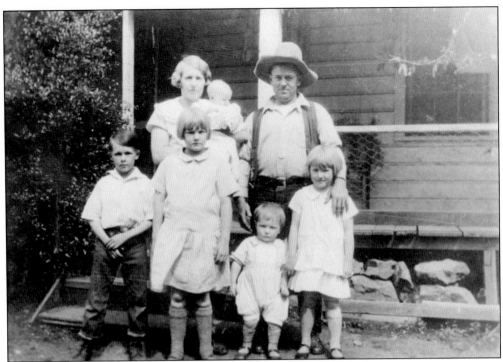

This photograph of Jesse Monroe Sanford and his wife, Nettie, and their children was taken around 1927. Nettie (holding baby Thelma) and Jesse are standing behind, from left to right, Glenn, Eva Mae, Jesse Ray, and Anabel. (Sanford family.)

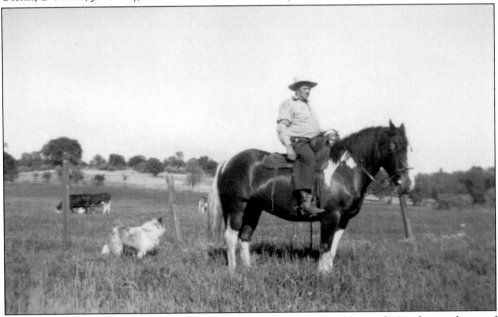

In 1914, Jesse Monroe Sanford (pictured) leased 1,500 acres of land located 18 miles southeast of Grass Valley in the Wolf district. From year to year, Jesse leased land varying from 1,500 to 4,000 acres on which he raised cattle and sheep. In 1926, Jesse bought the Underwood Ranch in the Wolf district, which included 640 acres and 200 acres on the hill. (Sanford family.)

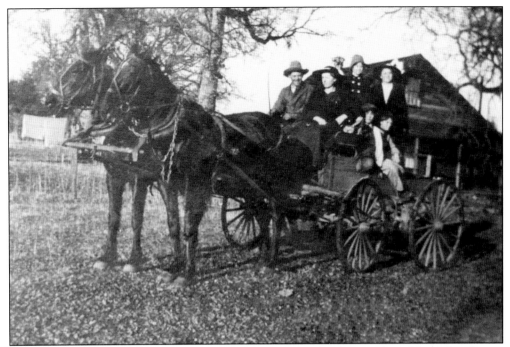

Jesse Monroe Sanford is driving the wagon, and also shown in the photograph are Nettie, Bea, Lottie, Dadie, and Earle Sanford at the Levi Ranch. In 1923, Jesse gave up the lease of the Underwood and Nichols land and went to Waldo, Yuba County, where he lased the David Jones Ranch and the Scott and Cabbage Patch Ranches, which totaled around 2,500 acres. (Sanford family.)

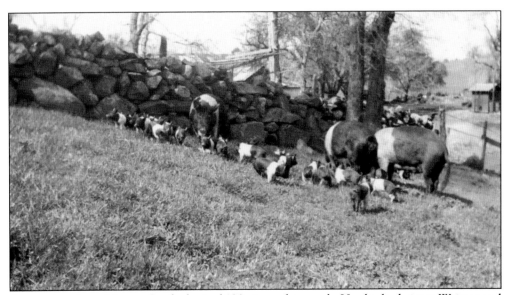

At one time, Jesse Monroe Sanford raised 100 pigs on his ranch. He also had pigs at Weimar and at Kings Beach in Tahoe, California. In total, he had about 1,500 pigs, and their feed was cooked by a steam engine. (Sanford family.)

Pictured here are Jesse Monroe Sanford (left) and his son Jesse Ray Sanford. The Sanfords drove cattle on horseback to the high county, Emigrant Gap, each spring and brought them home in early fall. The Sanford Reservoir, located near the intersection of Highways 20 and 80, is named after Jesse Monroe. He was a staunch supporter of the Nevada Irrigation District. (Sanford family.)

Jesse Ray Sanford (pictured), son of Jesse Monroe Sanford, was the best rifle shot in the area—there was no one known who could outshoot him. (Sanford family.)

Jesse Ray Sanford is standing between the two automobiles, and his father, Jesse Monroe, is at right. Jesse Ray had a valid driver's license when he was 12 years old because his father was sick. His first car was a 1931 Model Ford Coupe. After he served in the Army, he went to Veterans' School and studied animal husbandry and learned how to weld. (Sanford family.)

This is the 1946 graduation photograph of Dolores Barbara Butler, who graduated from Placer High School in Auburn, California. Her family moved to Grass Valley so that her father, John Werry Butler, could run the Butler Ranch on Lime Kiln Road after his four brothers went off to war. After she married Jesse Ray Sanford, she moved to the Sanford Ranch in South County, Grass Valley, and lived there for the rest of her life. (Sanford family.)

Jesse Ray Sanford was driving his cattle truck to Oakland, California, to move the family furniture to the family ranch in Nevada County when he met Dolores Barbara Butler, daughter of John Werry Butler and Edloe Myrvel Black. Dolores's family was living in Oakland, California, at the time but temporarily moved to Grass Valley during World War II. Jesse Ray and Dolores are pictured here around the time of their wedding in 1947. (Sanford family.)

William Sweet settled in Grass Valley in 1864. After giving up mining, he purchased land in the Wolf district. His wife, Katherine, and their children, Eliza, William, John, and Henry—along with their married daughter Ellen Partridge and her husband, Samuel, and infant son, Sam—arrived in 1871 from England on the ship *City of New York*. This photograph of William and Katherine was taken in Cornwall around 1850. (Sweet family.)

This 1890s photograph shows the five children of William and Katherine Sweet who were born in Cornwall. From left to right are William Sweet, Ellen Sweet Partridge, Harry Sweet, Eliza Sweet Carter, and John Sweet. John owned 100 acres of the original Sweet land, and he added an additional 580 acres where he raised stock. (Sweet family.)

The Wolf School opened on the Sweet Ranch on August 6, 1891. When brothers Don and Gary Sweet attended the school in the 1940s and 1950s, there was an average of 15 students each year. The school bell summoned the children in from recess, where they had 100 acres of ranch land as a playground. There was also a barn in the back with stalls for horses. (Sweet family.)

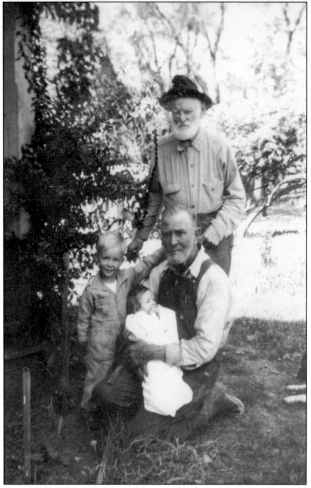

The Wolf Post Office pictured here first opened in the living room of the Sweet home. John Sweet was postmaster for 55 years. His nephew William Bernard Sweet took over as postmaster in 1940, and they were the only two postmasters until the closure of the Wolf Post Office in 1956. This post office served 75 families and the Wolf School. (Sweet family.)

John Sweet, former postmaster of the Wolf Post Office, is standing at the back of this 1940 photograph. John is pictured with his brother Harry Sweet and Harry's grandsons Gary (in Harry's arms) and Donald. John was six years old and Harry was an infant when they made the voyage to the United States from England with their family in 1871. (Sweet family.)

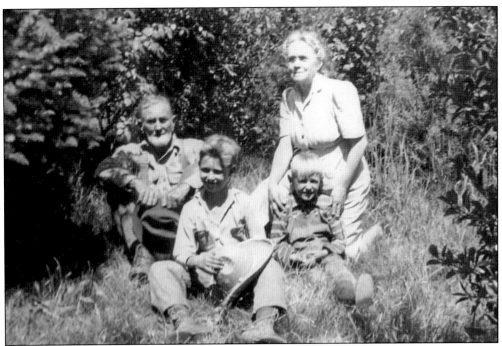

Harry Sweet was a charter member of the Banner Grange, an active and influential farm organization in the western portion of Nevada County. Harry farmed and ranched for his entire life in the Wolf district until 1948, when he and his wife, Mary, moved to Grass Valley. Pictured here are Harry and Mary with their grandsons Donald (left) and Gary Sweet. (Sweet family.)

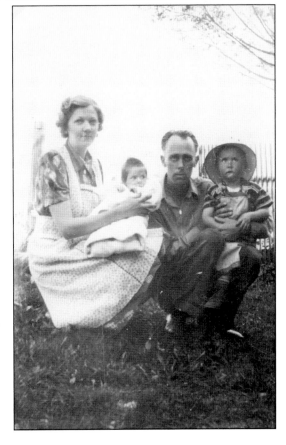

William Bernard Sweet, son of Harry Sweet, spent his whole life on the family ranch. He served as the postmaster of the Wolf Post Office from when his uncle John retired in 1940 until the post office was closed in 1956 because only two families still received their mail there. William and his wife, Alice, are pictured here in 1940 with their two sons, Donald (right) and Gary. (Sweet family.)

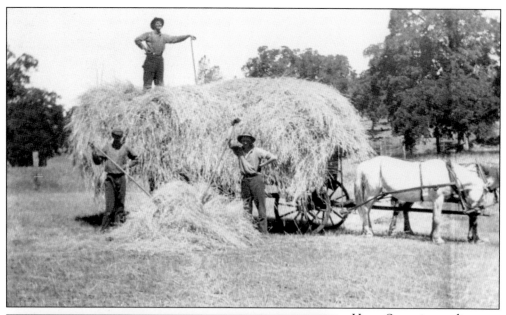

Harry Sweet is standing on top of the hay in the wagon and is the only person identified in this pre-1940s photograph. In the early days, the Sweet ranch in Wolf became a landmark, as the Sweet family was one of the earliest to homestead property in the southwestern part of Nevada County. Harry was the youngest of three sons; his brothers were William and John. (Sweet family.)

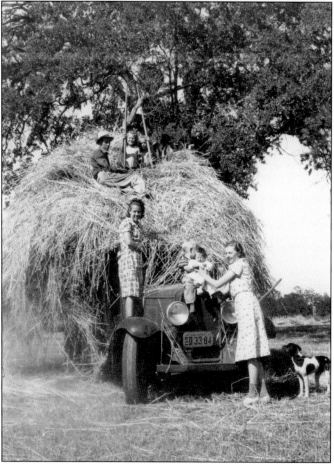

In this 1940 family haying photograph from the Sweet Ranch, William Bernard Sweet is sitting on top of the hay at left, and his wife, Alice, is standing in front of the truck helping to hold Gary, who is sitting on the lap of his brother Donald. The other people in the photograph are unidentified. (Sweet family.)

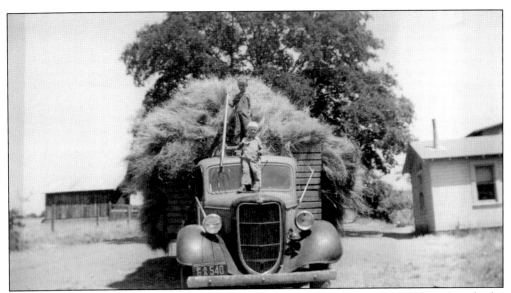

In this 1943 photograph, Gary Sweet is standing on the hood of his family's 1935 Ford truck; the other child is ? Dunbar. Gary worked for the Division of Forestry (now the California Department of Forestry and Fire Protection or CAL FIRE) after he graduated from high school at age 17. Gary started fighting fires on the ground and moved up the ranks—he was a captain when he retired in 1992. (Sweet family.)

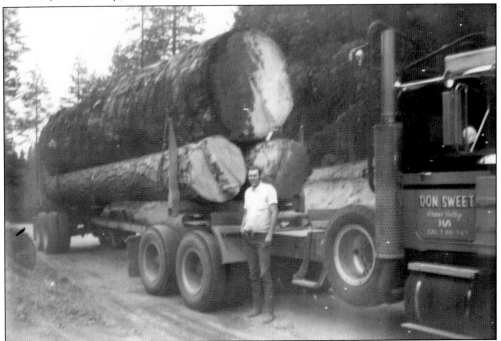

Donald Sweet owned his own business hauling logs and, at one time, worked for Lowell Robinson of Robinson Enterprises as he continued ranching. In 1984, after being encouraged to put in grapevines, he made the decision to grow and sell grapes to Nevada City Winery. When the recession hit in 2009, no one wanted to buy grapes, but Sweet stayed with it and got through with determination. (Sweet family.)

DISCOVER THOUSANDS OF LOCAL HISTORY BOOKS FEATURING MILLIONS OF VINTAGE IMAGES

Arcadia Publishing, the leading local history publisher in the United States, is committed to making history accessible and meaningful through publishing books that celebrate and preserve the heritage of America's people and places.

Find more books like this at
www.arcadiapublishing.com

Search for your hometown history, your old stomping grounds, and even your favorite sports team.

Consistent with our mission to preserve history on a local level, this book was printed in South Carolina on American-made paper and manufactured entirely in the United States. Products carrying the accredited Forest Stewardship Council (FSC) label are printed on 100 percent FSC-certified paper.